1000 SNEAKERS

This book was designed by Olo Éditions.
www.oloeditions.com
36, rue Laffitte – 75009 Paris – France

ORIGINAL CONCEPT Marçais and Marchand
EDITOR Nicolas Marçais
ART DIRECTOR Philippe Marchand
AUTHOR Mathieu Le Maux
TRANSLATOR Roland Glasser
GRAPHIC DESIGN AND LAYOUT Marion Alfano
EDITORIAL ASSISTANT Sara Quémener
IMAGE EDITING Franck Collomb

ACKNOWLEDGMENTS
Olo Éditions wishes to thank all the brands featured in this book, as well as relevant sneaker-related websites and blogs, including chausport.com, complex.com, enclothing.co.uk, footlocker.com, highsnobiety.com, hypebeast.com, locondo.jp, monogramoslo.blogspot.fr, nicekicks.com, packershoes.com, sarenza.com, shelta.eu, sneakeraddict.fr, sneakercollector.es, sneakerfreaker.com, sneakerhead.com, sneakernews.com, sneakerpedia.com, sportshoes.com, and trainerstation.com, and also photographer Michael Wa for their help.

Thanks also to Anastasia Benard (Stéphanie Protet agency), Claire Boulanger (New Balance), Linda Cortjens (AFG-INT), Grégory Crognier (Puma), Laurent David (Puma), Benjamin Devillard (Adidas), Camille Doux (Zmirov agency), Sven Eulitz (thevintager.de), Sonja Gerhards (Grayling), Florence Grimmeisen (Waterfilms), Laura Jouot (Converse), Catherine Ly (Spring Court), Joséphine Mangalaboyi (Nike), Patricia Menant (Reebok Showroom), Mathias Monge (Nike), Victoria Paturel (Le coq sportif), Elsa Salmon (Lecurie agency), Jean-Philippe Sionneau (Le coq sportif), Judith Teensma (Pony), and Laura Usseglio (Reebok Showroom).

The author would like to thank Charlotte Le Maux and Sabrina Rouvrais for their support and patience, Sara Quémener for her very precious help, and Julien Lambéa for his fashion expertise.

First published in the United States of America in 2016 by Universe Publishing
A division of Rizzoli International Publications, Inc.
300 Park Avenue South
New York, NY 10010
www.rizzoliusa.com

© 2015 Olo Éditions
Revised and updated in 2020

Ninth printing, 2021
2021 2022 2023 2024 / 14 13 12 11 10 9

ISBN: 978-0-7893-3255-4

Library of Congress Control Number: 2016937227
Printed in Bosnia & Herzegovina

Mathieu
Le Maux

1000 SNEAKERS

**A Guide to the
World's Greatest Kicks,
from Sport to Street**

UNIVERSE

I don't remember my first day at school nor my first party, and I have only vague memories of my first Christmas—all events that would usually be burned into a child's memory. My brain must have its own particular way of sorting things because I do, however, very clearly remember the day my parents gave me my first pair of sneakers. It was Thursday June 4, 1992, my eleventh birthday—undoubtedly the greatest birthday ever. It had taken some tough negotiations, incessant begging, and a fistful of good grades brandished as the ultimate proof to bring my parents to their senses, reluctant as they were to spend 500 francs on a pair of kicks—it wasn't so much a question of means as of principle, for they saw it as an idle fancy to which I unshakably clung. The idol of every kid at the time—or at least as far as I was concerned—went by the name of Andre Agassi, who lost that year's French Open semifinal to the inelegant machine that was Jim Courier—the tournament's eventual winner. The Las Vegas Kid, as Agassi was nicknamed, shook up tennis's staid, sober style with his grungy appearance, futuristic sunglasses, multicolored polo shirts, stonewashed denim shorts, and, holy of holies, his Nike Air Tech Challenge IVs that set a whole generation drooling. Of course, on that birthday morning, it wasn't the 1,000-franc model with the famous

Air Max sole that I laced up, but a less costly one. No matter. I finally had the look, dude! I can still see myself greedily eyeing up the object of my obsession on the way to school, enjoying its immaculate whiteness to the max, quite aware that such a perfect hue would not survive its "baptism." This tradition, which involved stamping on the feet of a classmate who was wearing a new pair of shoes, exasperated our parents—quite legitimately—but it was a rite of passage for each initiate to the cult of cool and a ritual that was repeated at each fresh acquisition. I usually ran about in pairs of Noël or Pony—second-division brands, which, in the social Darwinism of primary school, were still worth more than supermarket brands—but now I would finally get my toes flattened, as I entered the major league of sneakers, that of Nike, Reebok, and other champion brands. I have not been relegated since: twenty-three years later, my sneaker shelf contains more than 300 models, including a limited edition of the "real" Agassi, bought in two clicks of a mouse at some ungodly hour of the night. I rarely wear them. I must think about getting them baptized.

Mathieu Le Maux

ANATOMY OF A SHOE

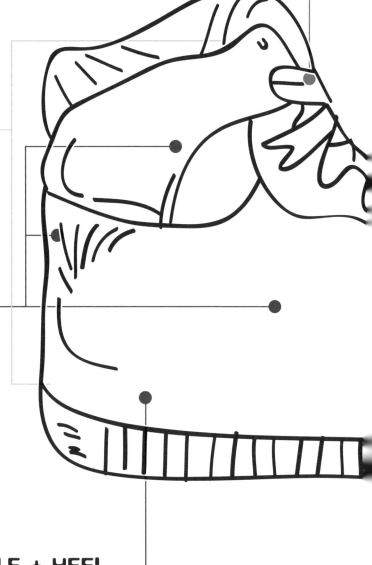

THE UPPER

Refers to all parts of the shoe above the sole.

HEEL PATCH + SIDE PANEL

These two parts of the shoe are quite strategic, since these are where brands place their logo.

MIDSOLE + HEEL

The midsole (often masked by the outsole) and heel are two vital organs, absorbing the shocks and vibrations caused when the foot strikes the ground after a stride or jump, and they have been the focus of dozens of technological innovations. The success of the sneaker industry hinges on this part of the shoe.

TONGUE

The tongue serves to protect and support the instep and the base of the ankle, and can be thin and discreet or thick and prominent. Along with the heel patch and side panel, the part situated above the point where the laces are tied is a special location where brands place their logo, their name, or the face and signature of their ambassador.

SHOELACES

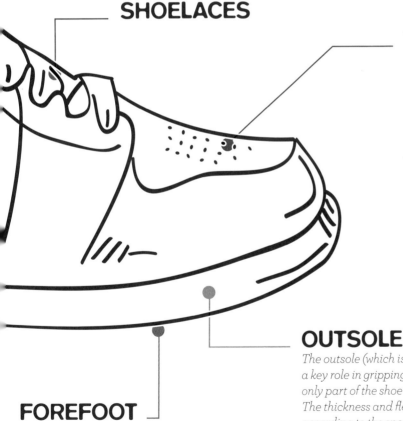

TOE BOX

The toe box is an envelope that fulfills the tricky double task of protecting the toes as much as possible, without cramping them, and ensuring their proper ventilation. Initially made of leather, today's toe boxes are made of sophisticated synthetic materials.

OUTSOLE

The outsole (which is below the midsole) plays a key role in gripping the ground, since it is the only part of the shoe in direct contact with it. The thickness and flexibility of the outsole vary according to the sport for which the shoe is intended.

FOREFOOT

The forefoot is an extension of, or an addition to, the midsole, depending on the model, and is designed according to the type of sport for which the shoe is intended. It must always be as supple as possible in order to match the flexion point of the toes.

CONTENTS

Anatomy of a Shoe 6

1. CREATING A CULT

2. REIGN OF THE BRANDS

3. TOP OF THE BASKET

CHAPTER 1

CREATING A CULT

A sneaker is not born great; it becomes great. How? By becoming part of the story of a sportsperson, an artist, a trend, or a cultural movement, to create its own legend. Air Jordan became great thanks to a charismatic athlete capable of turning it into the symbol of an entire generation. The Superstar was brought to glory through the words of a rap group, Run-DMC, who brandished it as a community emblem. Other models were fortunate enough to cross paths with a cop on a TV show (Starsky and the SL 72), a hero of the big screen (Bruce Lee and the Mexico 66 made by Onitsuka Tiger), an idolized singer (John Lennon and the Spring Court), a musical genre (hip-hop), or a popular leisure activity (fitness training, skateboarding, or running). Designers such as Tinker Hatfield, father of the Air Max and the Huarache, have some responsibility, as do revolutionary technologies (Reebok's Pump system, for example), but cult status is sometimes achieved as if by a miracle, with no other intervention than that of the street, which, with its codes and trends, can decide a shoe's fate. Some of these beautiful stories are as powerful as they are ephemeral. Others, such as those of Adidas' Stan Smith, Reebok's Classic, or Converse's Chuck Taylor, adored by an entire country or by millions of people incapable of explaining the origin of their devotion, will undoubtedly endure until the unlikely event that stocks run out.

QUITE SIMPLY CULT

2011

Adidas announces it is
ceasing production of the
Stan, due to poor sales.
The fans uncover the strategy:
create a scarcity in order
to make a bigger splash
upon relaunch, which is what
happens in 2014,
to great success.

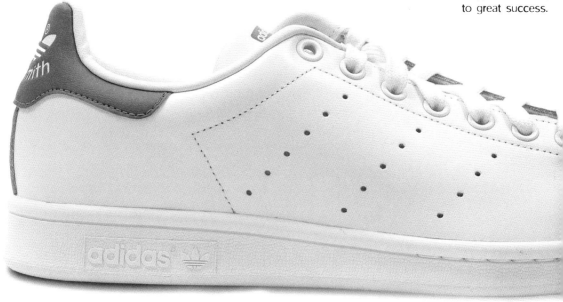

ROBERT HAILLET
The original

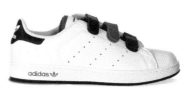

STAN SMITH 2
With Velcro

STAN SMITH HIGH/WMN
No comment...

"A lot of people now think I'm a shoe. They don't even know I was a tennis player. The shoe has really taken on a life of its own, way beyond me."

Stan Smith

With its clean lines, white leather, and compact profile, the Smith was applauded by all sneaker fans. A true miracle.

In 1963, Horst Dassler, CEO of Adidas, asked the French tennis player Robert Haillet to design the first leather tennis shoe, at a time when players the world over tortured their ankles in canvas models that were sorely lacking in support. Haillet's shoe was a technological exploit, featuring supple leather sewn directly to the sole. Eight years later, the German uniform supplier signed a contract with one of the best players at the time: twenty-five-year-old Stan Smith, winner of the 1971 US Open and stalwart of the US Davis Cup team. For three years, this Californian's name sat alongside that of the modest French player, before decorating the side of the shoe on its own. In the early 1980s, the Stan left the tennis court and hit the streets. It appeared on the feet of workers, teachers, and students wearing Levi's 501s and leather jackets. Ten years later, it became popular with rappers, before entering the Guinness Book of Records—nearly 22 million pairs had sold worldwide. The Stan has since become a fundamental accessory in the casual-chic wardrobe, rounding off the look of fortysomething bohos and fashion victims alike. The shoe was a favorite of the designer Marc Jacobs, and has been copied by great luxury brands numerous times, although never quite achieving the timeless aura of the original.

300

The price, in francs, of a Stan Smith in the 1980s. That is around 50 dollars, compared to 125 dollars today

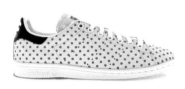

STAN SMITH PHARRELL WILLIAMS
Happy

STAN SMITH RAF SIMONS
Stand out

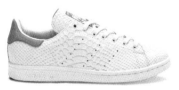

STAN SMITH CONSORTIUM
Reptilian

AN ICON, SOMEWHAT IN SPITE OF HIMSELF

We often forget that behind the name of this famous shoe stands a man, the tennis player Stanley Roger Smith, world number one in the early 1970s and winner of seven Davis Cups.

Stanley Roger Smith has been telling his story for the past thirty years, without ever tiring of it: "My name is known worldwide, thanks to a shoe. It appears on forty million pairs, but very often nobody knows who I am, or anything about my life, my career, or my achievements," he once said, without bitterness, in a corner of the Paris Adidas Store in April 2009, after having signed a dozen pairs of brilliant white shoes for a bunch of kids astonished at having found themselves face to face with the legendary player. World number one in 1972 and 1973, winner of two Grand Slams (1971 US Open and 1972 Wimbledon) and seven Davis Cups, this serve-volley veteran never complains about being mainly recognized for the shoe that bears his name. On the contrary, he explains: "In my day, nobody on the circuit made a fortune like they do today. When Adidas picked me [in 1971], I immediately became a privileged person, to much envy. I recall a South American player sponsored by Lotto, who had taken a pair of Stans and stuck his brand's sticker on them. I told him, 'Hey, those are my shoes you're wearing!' To which he replied, 'Yes, but please, Stan, don't tell anyone.' Many players wore the Stan because it was the best, and, at the same time, it irritated quite a few people that it carried my name. After all this time, and the success we all know it's had, the Stan has brought me much financial satisfaction, so what have I got to complain about?" Now head of a sports events company and a tennis school, the man who became a style icon in spite of himself still derives 50 to 60 percent of his income from his eponymous shoe: "The Stan Smith made me more of an entrepreneur than a dandy!" he jokes. "But what's most amazing about this shoe is that it suits everyone, from ordinary people to stars, such as Usher or Pharrell Williams. That is its true power."

Stanley Roger Smith, here seen serving at the 1978 French Open, was one of the very first world number one tennis players, from 1972 to 1973, before becoming an icon of sneaker culture.

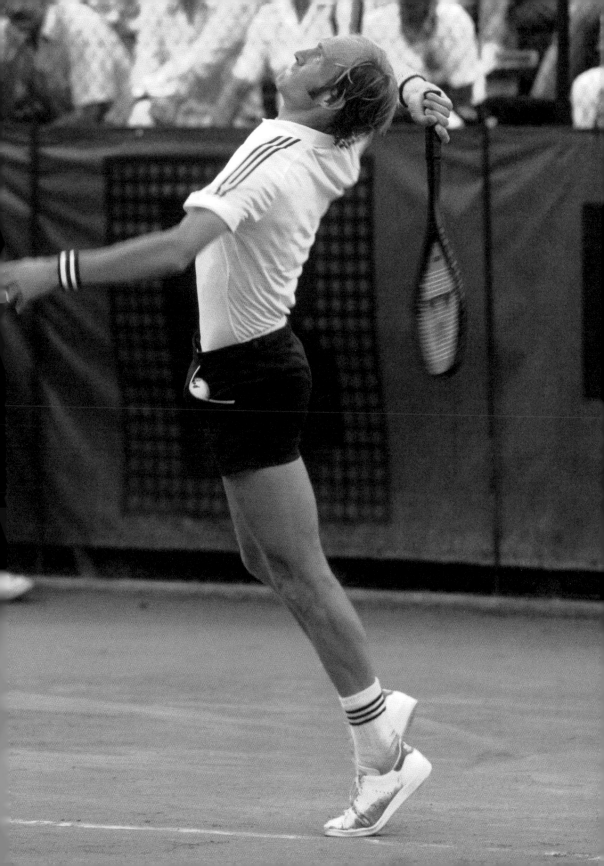

ADIDAS STAN SMITH

VINTAGE BLUE

ADIDAS X PHARRELL WILLIAMS

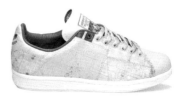

ADIDAS X STAR WARS
MILLENIUM FALCON

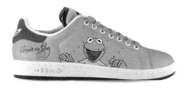

KERMIT THE FROG

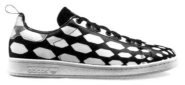

BATTLE PACK

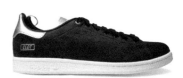

ADIDAS X CLOT

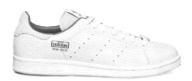

LUXURY PACK - SHARK WHITE

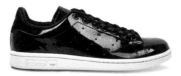

OIL SPILL

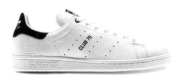

ADIDAS X CLUB 75

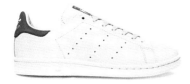

VINTAGE RED

ADIDAS X PHARRELL WILLIAMS
SOLID PACK BLUE

CORE BLACK & LEOPARD

ADIDAS X THE HUNDREDS

CONSORTIUM - PLAY

ADIDAS X CNCPTS

PRIMEKNIT

ADIDAS X PHARRELL WILLIAMS X COLETTE

ADIDAS X NEIGHBORHOOD

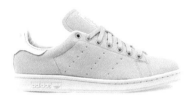

ADIDAS X PHARRELL WILLIAMS TENNIS PACK II

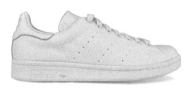

ADIDAS X PHARRELL WILLIAMS TENNIS PACK I

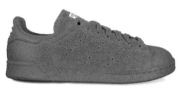

ADIDAS X PHARRELL WILLIAMS SOLID PACK RED

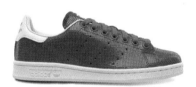

W POPPY

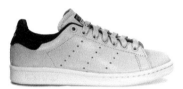

W CHALK

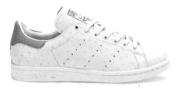

CONSORTIUM- OSTRICH

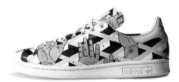

ADIDAS X OPENING CEREMONY

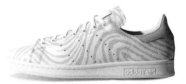

ADIDAS X OPENING CEREMONY

WOVEN

BASEBALL LEGACY

ADIDAS X OPENING CEREMONY

MASTERMIND

THE "GIRL POWER" SNEAKER

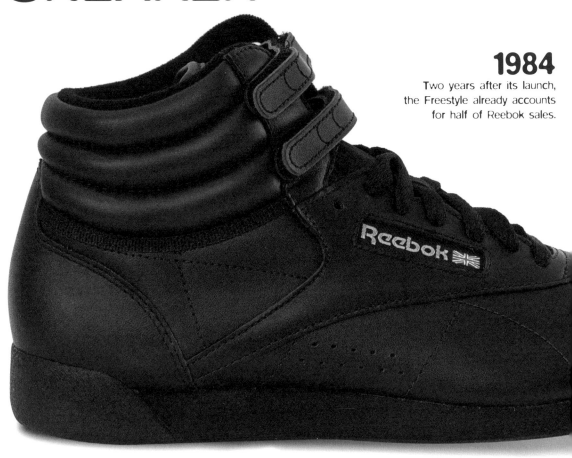

1984
Two years after its launch, the Freestyle already accounts for half of Reebok sales.

REIGN BOW
1980s icon

FREESTYLE WHITE
Cheerleaders' choice

EX-O-FIT
For men

EX-O-FIT

Name of the men's version of the Freestyle, launched five years after the original.

In the course of thirty years, this gym shoe designed for women has made its way from fitness classes to electro-pop gigs.

The year was 1982 when Reebok launched this distinctive high-top model made of soft leather, with its two Velcro closures and padded ankle collar. Specifically designed for women doing fitness training and aerobics—indoor sports were becoming increasingly popular at the time—the shoe was soon adopted by walkers, weight trainers, dancers, and, later, the cheerleaders of professional basketball teams (Reebok sponsored the Los Angeles Laker Girls). And just like many of its men's counterparts, the Freestyle soon leapt out of the gym and onto the street, specifically on September 22, 1985, when actress Cybill Shepherd attended the Emmy Awards wearing a bright orange pair with her black evening dress. The Freestyle became an icon for the Olivia Newton-John generation, whether worn with jeans, hot pants, sweatpants, or leggings. Their daughters are still wearing them thirty years later, notably to concerts by French electro-pop singer Yelle, a world ambassador for this timeless model.

307
BILLION DOLLARS

The global revenue for the Freestyle after just one year of sales.

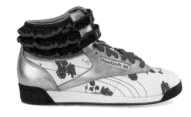

FREESTYLE WORLD TOUR (MADRID)
The "Madrid" special

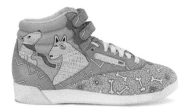

FREESTYLE 25TH ANNIVERSARY
Homage to the original

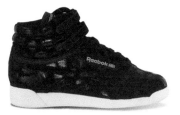

GRAPHIC
Elegant

THE HEN THAT LAID THE GOLDEN EGGS

1968

Bill Bowerman, track and field coach and cofounder of Nike, finishes designing the Cortez, four years before its launch.

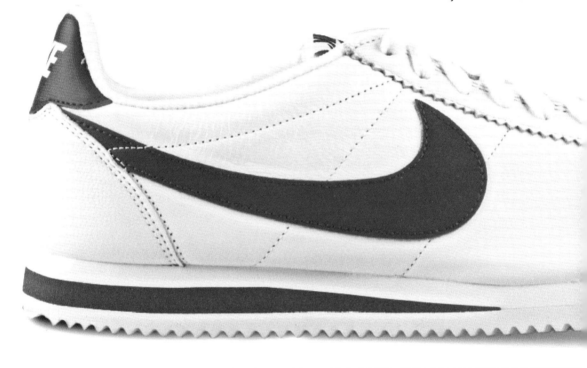

FORREST GUMP

2012 version

CORTEZ BLACK & WHITE

Effortlessly cool

ART & SOLE PACK

Special 40th anniversary

NIKE ID

It was the Cortez that was used to launch the personalization system in 2003.

Phil Knight and Bill Bowerman made their fortune with the Cortez. Having launched Nike in 1971, their first shoe to go on sale was the Cortez—released in 1972. It was an instant success across the United States.

"That day, for no particular reason, I decided to go for a little run." So begins Tom Hanks' long jog across the United States, in the film *Forrest Gump*, as he seeks to mend his broken heart by running. First he runs through his town, then his county, then his state, then his country. On his feet is a pair of Cortez shoes, which he never takes off. Initially called the Tiger Corsair, due to a partnership agreement between Blue Ribbon Sports (the firm's name before the famous Swoosh) and the Japanese brand Onitsuka Tiger, Nike's first track shoe was created in 1972, and won over the general public, who saw it on the feet of athletes at the Olympic Games in Munich. The success of the Cortez boosted Nike's sales from $8,000 to $800,000, and within a year, an empire was born. Comfortable, ultraminimalist, and available in numerous versions—including a more tapered women's model (the Señorita)—the Cortez has discreetly endured to this day, worn by hip-hop youth in the mid-1990s, as well as at the gym, and in retirement homes.

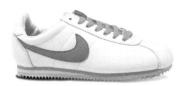

NIKE CORTEZ ID
2003: the first customized Nike

NYLON (QUILTED PACK)
The trendiest, with nylon upper

ONITSUKA TIGER CORSAIR
The inspiration

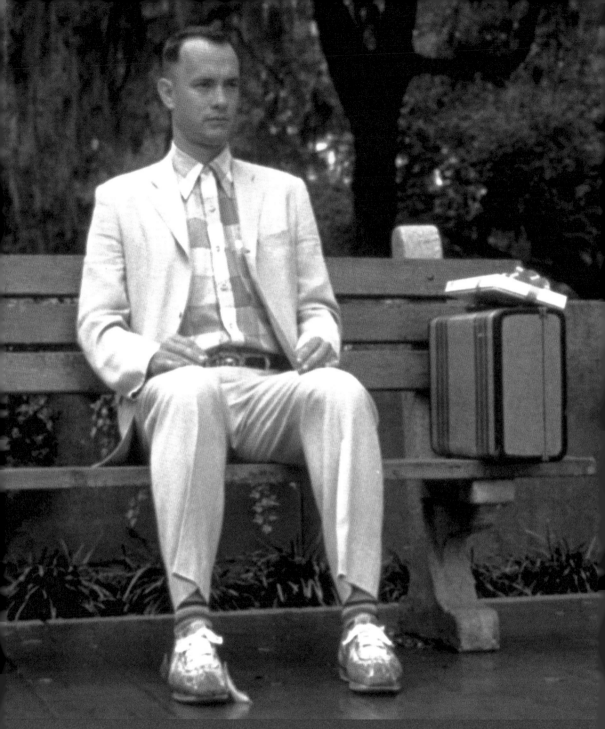

FORREST GUMP, 1994

Jenny gives Forrest a pair of Nike Cortez "made especially for running," and the hero then spends more than three years jogging across the United States in an attempt to forget his heartache. This sequence from Robert Zemeckis' film—a historical fresco of the United States from the 1950s to the 1980s—illustrates the jogging boom of the early 1970s.

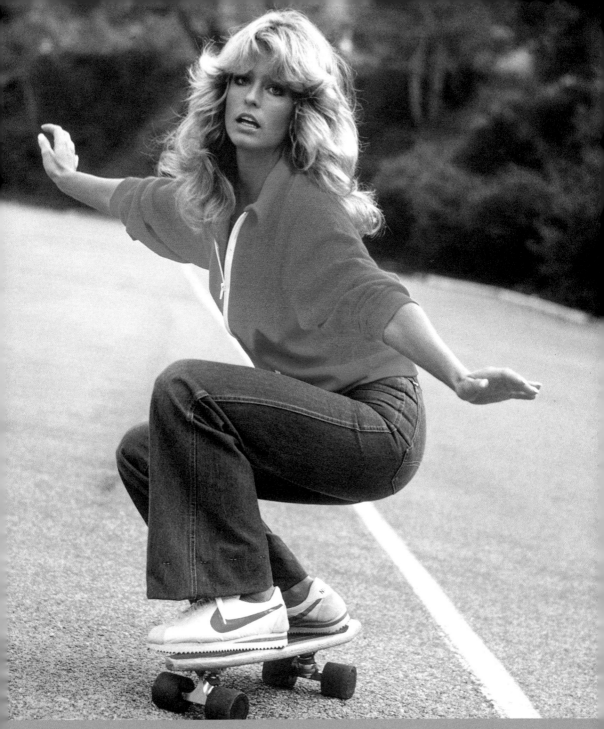

CHARLIE'S ANGELS, 1976

Farrah Fawcett—aka Jill Munroe in this cult series from the 1970s—on the set of the tenth episode of the first season.

ONE FOOT IN HISTORY

1971

Launch of the Pelé Brazil, for which the Clyde served as the base model.

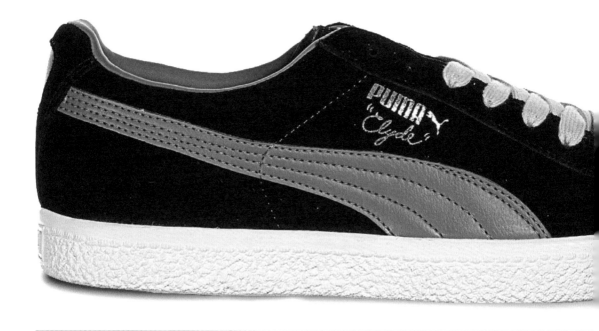

PUMA SUEDE
Big sister

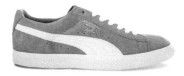

PUMA CLYDE GREEN
One of the many color options

PUMA CLYDE X FRANKLIN & MARSHALL
Vintage limited edition

"Puma came to me, and I think my first deal was $5,000—all the shoes I could wear. And then right after that, we won the championship, so they came out with the suede versions."

Walt Frazier

Puma's cult sneaker, seen here in the suede version designed for the basketball player Walt "Clyde" Frazier, has its fans in all musical genres.

In 1968, Rudolf Dassler, the founder of Puma, met Walt Frazier, the New York Knicks playmaker, nicknamed Clyde—in reference to Bonnie and Clyde—because of his skill at stealing the ball from his adversaries. Frazier, who was known for his eccentric dress, asked Dassler to design a special model for him. That same year, at the Olympic Games in Mexico City, Tommie Smith, the winner of the 200-meter dash, lowered his head and raised a black-gloved fist in the air in support of Black Power during the medal ceremony, as "The Star-Spangled Banner" was played. Before stepping onto the podium, he took care to remove his pair of black Puma Suedes, an act intended to symbolize the poverty of African-Americans, but which also inadvertently showcased the Puma Suede to the world. Puma took this history-making model as the basis for the Clyde, designed in 1973, with a couple of key differences (no logo on the heel and a thinner, wider sole). Although often worn by skateboarders, it was in the world of music that the Clyde really made an impact. B-boys, rastas, and grunge and acid-house musicians fell for this suede model, despite a temporary threat from that awful trend of fat laces. The Clyde was produced in an incalculable range of colors, and is still the brand's best seller.

2

The number of its rivals: the Superstar in hip-hop and the Gazelle on the acid-jazz scene.

PUMA PELÉ BRASIL
Fit for a soccer player

CLYDE FRAZIER LIMITED EDITION
The homage

FAT LACES
B-boy trend

PUMA CLYDE

PUMA CLYDE X UNDEFEATED
LUXE 2

URB PACK

LEATHER FS

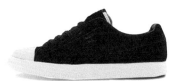

COVERBLOCK

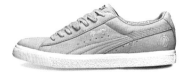

EASTER

GAMETIME

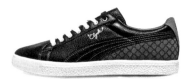

JET SET

PUMA CLYDE X VAUGHN BODE

MONSTER PACK - MOTH KING

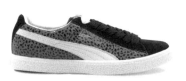

PUMA CLYDE X YO! MTV RAPS

MICRODOT

PUMA CLYDE X UNDEFEATED
BALLISTIC PACK

PUMA CLYDE X MITA SNEAKER

CLYDE WALT FRAZIER

PUMA CLYDE X SERGIO ROSSI

PUMA CLYDE X UNDEFEATED
SNAKE SKIN

PUMA CLYDE X SNEAKERSNSTUFF

PUMA CLYDE X UNDEFEATED
STRIPE OFF

TC LODGE

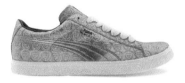

PUMA CLYDE X TOMMIE SMITH
MEXICO CITY PACK

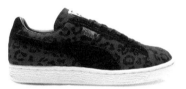

SUEDE ANIMAL PACK

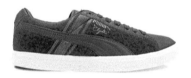

CLYDE SURVIVAL RED

CHASE - LONDON

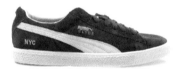

CHASE - NEW YORK

FUTURE CLYDE LITE X UNDEFEATED

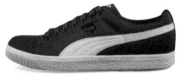

PUMA CLYDE X UNDEFEATED
NYLON EDITION

ECO ORTHOLITE

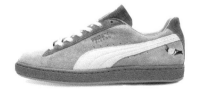

PUMA CLYDE X JEFF STAPLE
PIGEON

SCRIPT

PUMA CLYDE X YO! MTV RAPS

SAVED BY THE FASHION WORLD

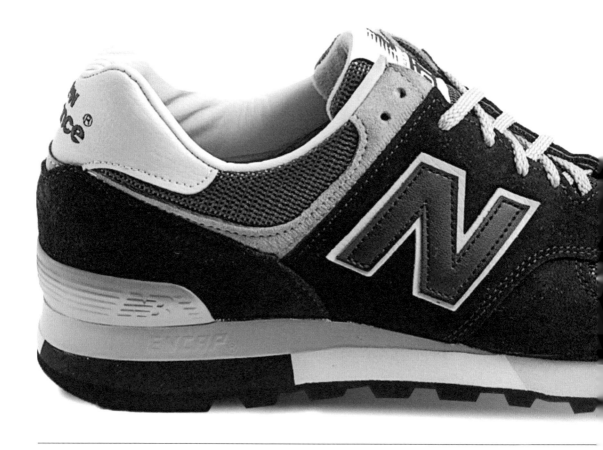

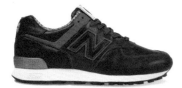

PUB PACK
City slicker

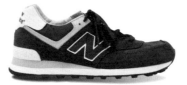

574
Twin sister

20TH ANNIVERSARY
The homage

58

*The number of pieces
required to make
each shoe.*

PHARRELL WILLIAMS

*The American singer was an
unofficial brand ambassador
for the 576, before signing an
endorsement deal with Adidas.*

Made in Europe, and adored by the fashion world and hip fortysomethings, this sneaker has become a chic basic, following a rather inauspicious launch.

Flimby is a village of 2,000 inhabitants on the west coast of England. It's difficult to believe that here, amid rolling green hills thronged with black-headed sheep, the American firm makes 1.3 million pairs of the 576 each year. This track shoe was a flop when it was first launched in 1988. Destined for the scrap heap, the entire stock of shoes was bought by a German industrialist, who happened to be visiting the firm's head office in Boston. The 576 was an immediate success in Germany, then in Italy and France. In Paris, stylists paired this sneaker—which had no equivalent at the time—with both the radical chic of Helmut Lang and the casual luxury of Ralph Lauren. The model would go on to sell up to 16 million pairs a year throughout the world. In 1998, *Elle* magazine gave it a new lease on life by featuring three top models wearing 576s while dressed as soccer players for a special World Cup cover. It was a nice bit of marketing for a brand that had hitherto never

*The 576 is only
produced in the
United Kingdom.
Its American sister
is the 574.*

used a female brand ambassador. Despite a bit of a decline in the early 2000s—following some dubious color choices—the 576 has remained a perennial staple of the fashion world.

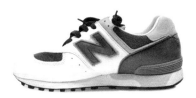

CROOKED TONGUES
London style

WILL & KATE
Fit for royalty

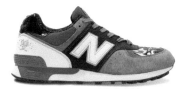

CHINA MASK
Special Beijing Olympics

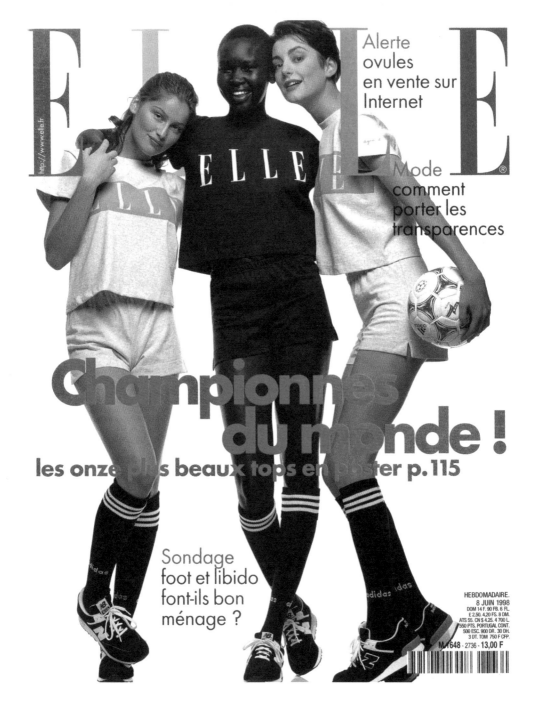

The cover of the June 1998 issue of French *Elle* magazine. This reinvigorated the brand, which had been falling behind in the lifestyle sector.

NEW BALANCE ON THE COVER

ON PHARRELL'S FEET

Before being signed by Adidas, the rapper Pharrell Williams regularly wore New Balance 574 on stage. This was essentially free advertising for a brand, which, up until 2013 and its partnership with the Canadian tennis player Milos Raonic, had never called upon the services of a brand ambassador.

NEW BALANCE 576

ML574

ML574APB

M576BRM

ML574BL

ML574CPR

M574CVN

ML574FTG GREEN

ML574GS

ML576 FRANCE

ML576 THREE PEAKS PACK

ML576 CHINA MASK

ML576FC

M576MOD

ML576 TEA PACK - PEPPERMINT

ML576PGT

ML576TPM

ML576RED

ML576PUN

WL574 NEON PACK - NED

WL574APP

WL574CPW

WL574RP

WL574SBS

WL574PBU

ML574RFO

M576KGS

M576TGY TEA PACK - EARL GREY

M576DNW

M576SRB

M576SGA 25TH ANNIVERSARY

K-SWISS CLASSIC

FIVE STRIPES OF COOL

2014
K-Swiss relaunches its vintage models with Ed Westwick, the actor from *Gossip Girl.*

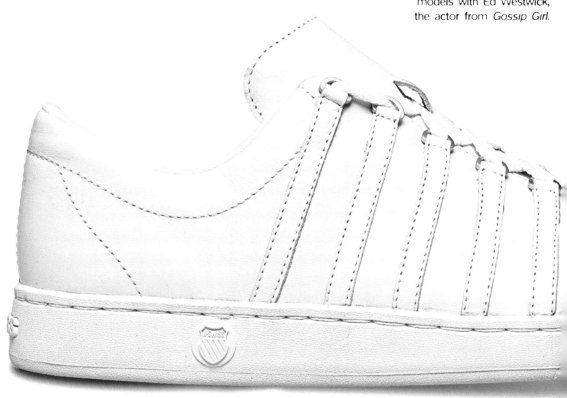

CLASSIC

Five stripes on the side and two on the toe

CLASSIC LITE

Canvas upper

LUXURY EDITION

Even more comfortable

The K-Swiss Classic is little worn in Europe, but this tennis shoe from the 1960s and 1970s is a pillar of American sportswear, after becoming a firm favorite of the hip-hop community.

No sneaker has more stripes than a K-Swiss: five in all, without counting the two stripes sewn onto the toe of the Classic —the California brand's flagship model, which was launched in 1966 and was aimed at tennis players. Strangely, this particularity, along with a brilliant white leather and D-shaped metallic eyelets, was a success, even though this multistripe design sometimes made it look like a fake Adidas shoe. Founded by two Swiss brothers, Art and Ernie Brunner, K-Swiss sneakers can also be found on the feet of aerobic-loving American mothers, cosmopolitan graphic designers, and hipsters seeking to stand out from the hordes of sneaker addicts. The singer Gwen Stefani has endorsed them, as have numerous rappers—proof that the brand has become cool again. And any doubts about the shoes' solidity were dispelled when Sébastien Foucan wore them during the breathtaking freerunning chase scene that opens the James Bond film *Casino Royale*.

SWIZZ BEATZ

The New York rapper Kasseem Dean was given this nickname as a child because of his fondness for wearing K-Swiss sneakers.

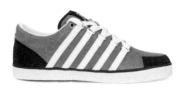

GOWMET
From tennis to basketball

K-SWISS X PARTNERS & SPADE
Very limited edition

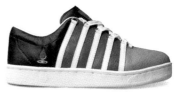

ELEMENT PACK
Water

PLANET RAP

75%

of players in the NBA in the early 1970s wore Superstars for their games.

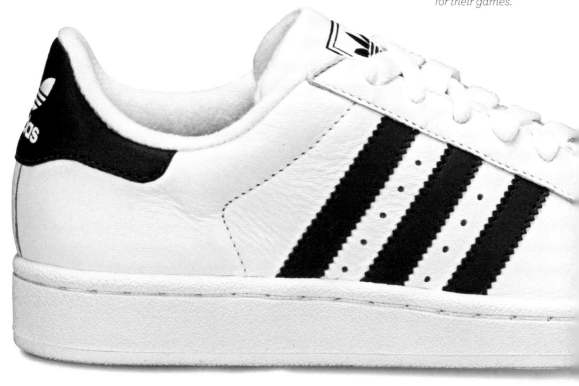

RUN-DMC SUPERSTAR

Legendary model

LA PRO-MODEL

Slick high-top

CLEAN PACK

The sleekest

Forever associated with the rap group Run-DMC, the iconic shoe of hip-hop culture made an incredible comeback in 2014 and 2015.

Adidas Superstar, the first low-top, leather basketball shoe ever made, hit the courts in 1969, and was immortalized by the elegance of Kareem Abdul-Jabbar, before becoming a street icon of the hip-hop scene fifteen years later—as did many of its peers from other brands. But the rap group most associated with it is Run-DMC. In 1986, these New Yorkers hailed their favorite sneaker in "My Adidas," launching the tongue-out, laces-untied style. At concerts, the audience members would wave their own pairs in the air. The highly recognizable rubber shell toe box became a rallying symbol. Adidas sensed the commercial potential of the rappers from Queens and signed a $1 million endorsement deal with them. This made Run-DMC the first non-sports ambassador for a sportswear brand. In the mid-1990s, the Superstar's rebel spirit attracted skateboarders —who began to turn their backs on Vans—followed by high school students, who, like the New York B-boys, wore them with fat laces. In 2005, Adidas celebrated the thirty-fifth anniversary of the shoe by bringing out thirty-five models customized by different musicians, artists, and fashion designers. Ten years later, the privilege was extended to all via the brand's customization platform. The most sought-after Adidas Superstars are those made in France, which are said to be better finished.

METAL TOE
Cheeky

SUPERSTAR X PHARRELL WILLIAMS
Bolivian inspired

LUXE
On trend

ADIDAS SUPERSTAR

RITA ORA X ADIDAS SUPERSTAR

BRONX

GOLF

OG BLACK

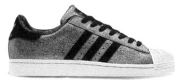

YEAR OF THE HORSE

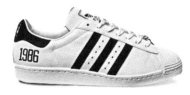

RUN-DMC "MY ADIDAS"

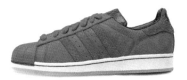

CHINESE NEW YEAR

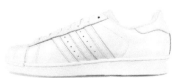

PHARRELL WILLIAMS X ADIDAS
SUPERSTAR SUPERCOLOR PACK

CLOT X KAZUKI X ADIDAS
SUPERSTAR ROYAL BLUE

BLOOD DRIP

NEIGHBORHOOD X ADIDAS
SUPERSTAR

RITA ORA X ADIDAS SUPERSTAR
O RAY PACK

GRAFFITI PACK

JAMES BOND

UNION X ADIDAS SUPERSTAR

KERMIT THE FROG

WATERMELON

RUN-DMC X KEITH HARING X
ADIDAS SUPERSTAR

RITA ORA X ADIDAS SUPERSTAR

TRIBE (BLUE SNAKE)

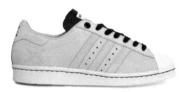

3-WAY

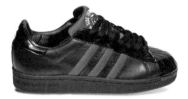

STAR WARS X CLOT X ADIDAS
SUPERSTAR DARKSIDE STAR

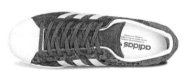

DOT CAMO PACK

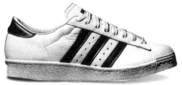

MADE IN FRANCE

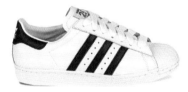

SUPERSTAR BY NIGO

XENO

PHARRELL WILLIAMS X ADIDAS
ORIGINALS SUPERCOLOR PACK

FOOTPATROL X ADIDAS
SUPERSTAR

NYLON PACK - TEAL ROYAL

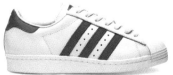

OG RED

FASHION VICTIM

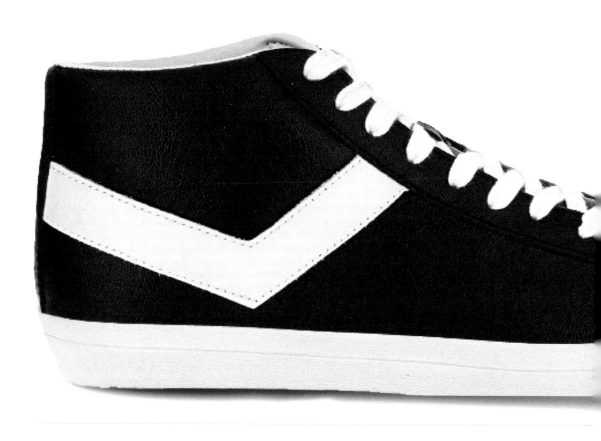

TOP STAR X COLETTE

The French touch

TOP STAR X MARK MCNAIRY

Daring

TOP STAR X DEE & RICKY

Showy

The Top Star was the shoe of American basketball in the 1970s, and is now a collector's item.

We often forget that before the Jordan era, the Dream Team of the 1992 Barcelona Olympics, and the wild years that followed—when sneaker sales shot through the roof—American basketball had an earlier golden age, under the aegis of the American Basketball Association (ABA). It was in this professional league—founded in 1967 and swallowed up by the NBA nine years later—that Pony, the official sponsor, launched the Top Star, in 1975. The shoe was made in both basic leather and suede versions, and was produced in the colors of the various franchises; it cushioned the leaps of the Afro-styled basketball players with their white socks pulled up to the knees. The Top Star was gradually adopted by kids in New York's uptown neighborhoods, who later came to prefer the brand's Uptown and City Wings models—with their similar genetic code—in the 1980s. The Top Star disappeared along with the brand, pushed to the sidelines by Nike and others, to be found only in discount stores. Relaunched in 2001, Pony now works with fashion designers and niche stores (Dee & Ricky, Mark McNairy, and Colette) to keep the brand fresh and young.

TOP STAR LOW
Discreet

TOP STAR X FOOTPATROL
British style

TOP STAR X MADE IN BROOKLYN
B-boy

BEAUTIFUL REBEL

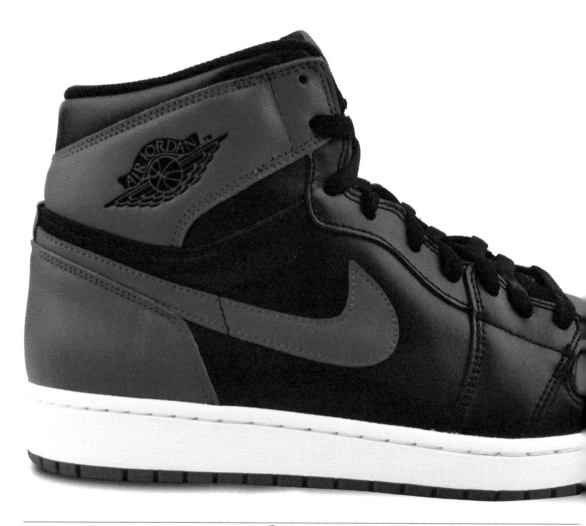

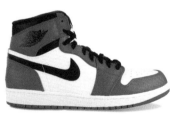

AIR JORDAN 1 (SECOND VERSION)
White and red, for the NBA

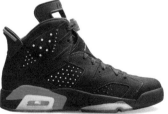

AIR JORDAN 6 INFRARED
Impossible to find

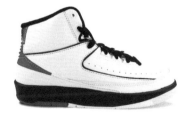

AIR JORDAN 2
Made in Italy

126 MILLION DOLLARS

Sales revenue generated by the Air Jordan 1 within the first year after its launch. Nike had been hoping for "just" three million over four years.

Initially banned by the NBA, the Air Jordan 1 was the first in a long line to disrupt sneaker culture in the mid-1980s.

In answer to the question "What shoe would you take with you to a desert island?" there's a strong chance that a sneakers addict would immediately answer, "An Air Jordan!" And out of the twenty-nine models—each of which was produced in dozens of versions—he or she would specify, "The first one, of course!" Worn by a charismatic genius, the Air Jordan 1 is the most venerated sneaker on the planet, the icon of a virtual religion. Yet the shoe was very nearly throttled at birth. For a start, the Chicago Bulls player himself refused to wear the sneaker when he first laid eyes on it. "I'll look like a clown!" he said. Later, the main obstacle came from the very rigid NBA. Its regulations required sneakers to have a minimum amount of white on them, so it banned this entirely red and black shoe. And that might have been the end of it, except the ban became the most wonderful marketing opportunity. Nike paid a $5,000 fine every time MJ wore the forbidden footwear, and consumers were soon converted. The American uniform supplier, who had already had its previous Jordan model—the Air Ship— banned, upped the ante in a spirited TV ad that announced, "The NBA threw them out of the game. Fortunately, the NBA can't stop you from wearing them." We all know how very effective that ad campaign was.

560 000 DOLLARS

Auction price of a pair of AJ1's (autographed by Jordan) sold at Sotheby's on May 17, 2020 —a new world record.

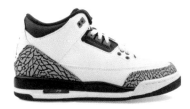

AIR JORDAN 3 INFRARED
Tinker Hatfield's first

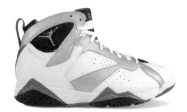

AIR JORDAN 7
Most televised

AIR JORDAN 18
Most ephemeral

THE JORDAN BUSINESS IN 20 STATS

Arguably the best basketball player of all time is also the most bankable sportsperson in the world. Here are the details of a very juicy business.

PERSONAL ASSETS

1.7 BILLION DOLLARS

Total earned by Michael Jordan off-court over forty years, thanks to his promotional deals, principally with Nike, Coca-Cola, McDonald's, and Chevrolet.

100 MILLION DOLLARS

Deal offered to Michael Jordan by a sponsor in 2017 to attend an event for two hours and which he took the liberty of turning down.

1001

Ranking Michael Jordan holds in the Forbes Billionaires 2020 list of the richest people in the world.

300 MILLION DOLLARS

Sum earned by Michael Jordan in September 2019 after selling a number of shares in the Charlotte Hornets—an NBA franchise of which he remains the majority shareholder (70%).

94 MILLION DOLLARS

Michael Jordan's total earnings (before taxes) as a player during his fifteen seasons with the NBA (thirteen with the Chicago Bulls, two with the Washington Wizards).

145 MILLIONS DOLLARS

Amount that Nike paid Michael Jordan in 2019.

34,246 DOLLARS

Michael Jordan's hourly earnings, as calculated by Business Insider US.

2.1 MILLION DOLLARS

Michael Jordan's estimated fortune following the Forbes ranking of May 2020.

AIR JORDAN

65 DOLLARS
Price of the Air Jordan 1 in 1985.

450,000 DOLLARS
The total value of Air Jordan 1's sold less than a month after their initial release in the United States.

95%
Nike and Jordan sneakers' share of the eBay resale market.

145 DOLLARS
Average price of an Air Jordan in 2020.

812 DOLLARS
Average price of an Air Jordan 1 High x Fragment on eBay.

36 MILLION DOLLARS
Turnover generated by the Air Jordan X "Powder Blue" in a single day in 2014.

5,000 DOLLARS
Fine paid by Michael Jordan for each match played with the Jordan 1 on NBA courts in 1985.

35,000 DOLLARS
Price of a pair of shorts and a jersey worn by Michael Jordan in his final season with the Chicago Bulls (1997-1998).

3 HOURS
Time taken to sell the entire stock of Air Jordan XI "Legend Blue" on December 20, 2014, for a total of eighty million dollars.

JORDAN BRAND

3.1 BILLION DOLLARS
Total revenue of the Nike subsidiary Jordan Brand 2018-2019, an increase of 10% on the previous year.

58%
Jordan Brand's share of the basketball shoe market in the United States.

1,600 DOLLARS
Price of the most expensive bottle of the premium tequila brand launched by Jordan in partnership with three other NBA franchise owners.

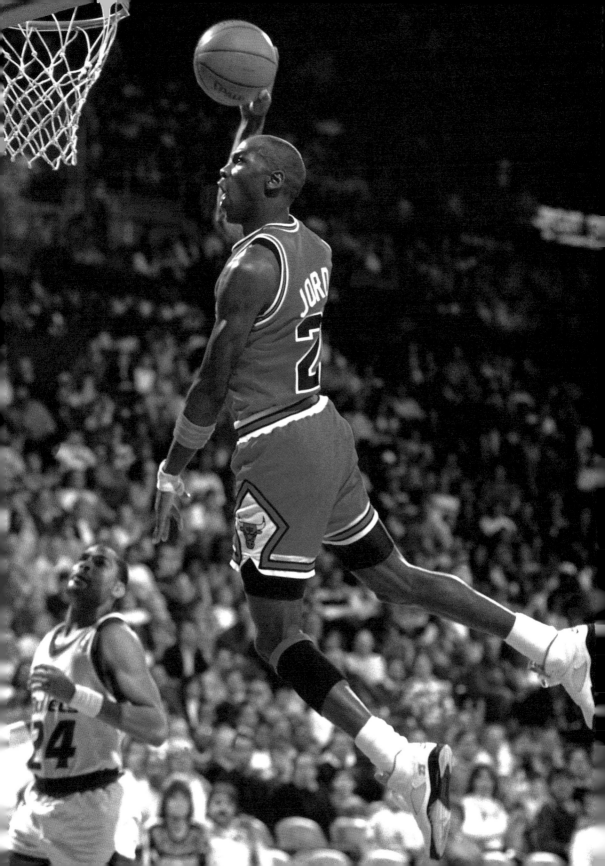

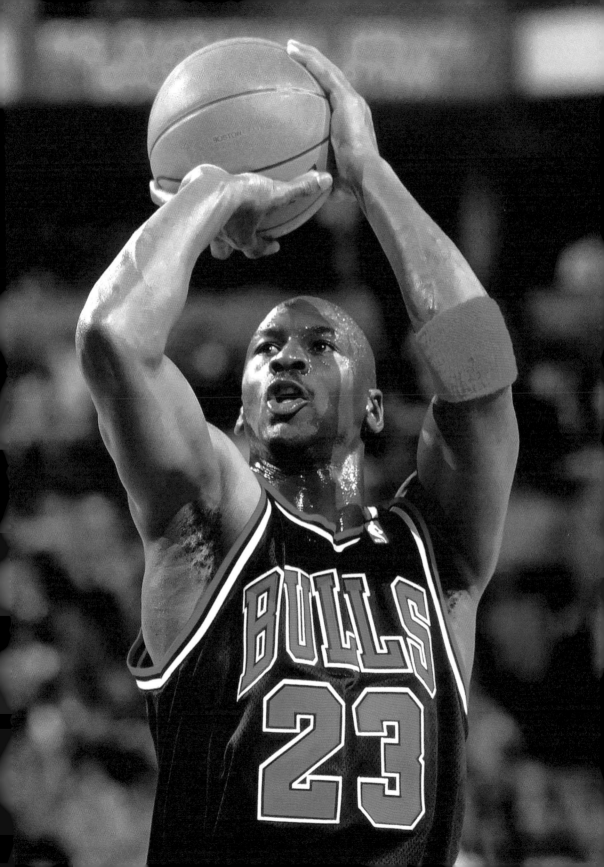

NIKE AIR JORDAN

AJ 1 JAPANESE

AJ 5

AJ 3

AJ 9

AJ 6

AJ 8

AJ 19

AJ 10

AJ 14

AJ 12

AJ 13

AJ 11 BRED

AJ 1 2015

AJ 29 YEAR OF THE GOAT

AJ 5 X MARVEL
CAPTAIN AMERICA

AJ 4

AJ 20 FUSION

MELO M10 BHM

AJ 23

AJ 8 SUGAR RAY

AJ 1 WINGS FOR THE FUTURE

AJ 14 FERRARI

AJ 15

AJ 26

AJ 5 DOERNBECHER

AJ 22

AJ 17

AJ 5 OREO

AJ 8 AQUA

AJ 16

EATING UP
THE ROAD

October 25,
2008
Launch of the Easy Rider
Machine Wash limited edition.

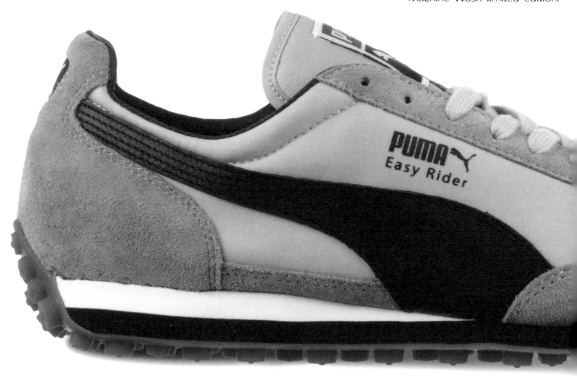

EASY RIDER
Innovative grip

FAST RIDER
Older sister

EASY RIDER III
New generation

MAGNUM

The Easy Rider rounded off Tom Selleck's Hawaiian look on the TV series Magnum, P.I.

Puma's first jogging shoe disrupted running in the late 1970s.

In 1978, at the height of the jogging boom—involving nearly 26 million Americans, Puma brought the Fast Rider and the Easy Rider to the running market. These two sister models were as supple as they were sturdy, and the soles were covered in small cleats—a major technological advance that would be widely copied by the brand's rivals. This innovative sole was intended to absorb shock better and grip the road more, as well as helping to avoid slides and tumbles in wet ground, and allow runners to venture off the flat onto rougher, more slippery terrain. The combination of a sleeker profile with these little cleats made the Easy Rider very attractive to joggers on the West Coast, who wore the shoe with long socks pulled right up to the knees and split shorts. Rereleased in late 2008 as the Easy Rider III, the sneaker was an immediate hit with trendsetters, street golfers, and fixed-gear cyclists. A beautiful new lease on life.

RS 100

The Easy Rider's little sister, launched in 1986.

PUMA RS 100
The high-tech version

MACHINE WASH
Proper 1970s

EASY RIDER BLUE AND YELLOW
Fixed-gear style

STAR OF THE SILVER SCREEN

1951

The first version of the Tiger helps the Japanese runner Shigeki Tanaka to win the Boston Marathon.

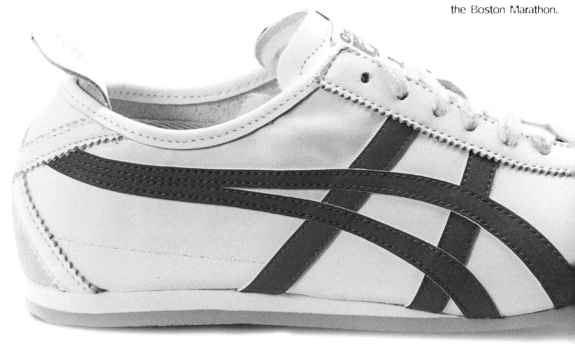

MEXICO 66 YELLOW AND BLACK
Bruce Lee's sneaker
in *Game of Death*

TAI-CHI
Uma Thurman's shoe in *Kill Bill*

RIO RUNNER
The descendant

Immortalized by Bruce Lee in *Game of Death*, this sprinter's shoe was the first to bear the famous logo of the Japanese brand.

Designed in 1966 by the Japanese shoemaker Kihachiro Onitsuka —founder of the brand that would become ASICS in 1972—the Tiger was worn by the Japanese track and field team at the Mexico City Olympics two years later. The distinguishing feature of the Mexico —whose very thin leather was particularly well suited to a sprinter's stride—was the set of "scratch marks" across the sides, which appeared here for the first time, echoing the brand's tiger head logo, a symbol of power. Ten years later, Bruce Lee used a yellow and black model to karate kick Kareem Abdul-Jabbar in *Game of Death*. The scene left a strong impression on the filmmaker Quentin Tarantino. In his film *Kill Bill* (2003/2004), Uma Thurman wears a pair of yellow and black

Bruce Lee's Mexico inspired a Nike model, the Zoom Kobe V.

Tai-Chi model (one much used in the martial arts). The Mexico is recognizable by the little tongue at the top of the heel collar, although it is sometimes confused with the Ultimate 81—a similar model with a part-mesh upper and a waffle sole.

MEXICO 66 ESPADRILLE
For the beach

MEXICO MID RUNNER
High-top version

ZOOM KOBE V
Nike's homage

AIR BUBBLE CUSHION

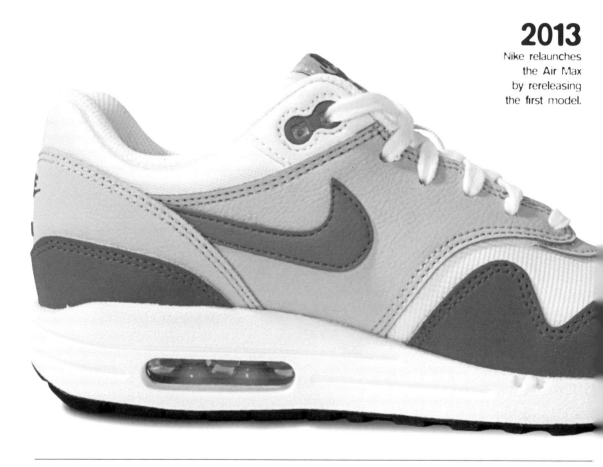

2013
Nike relaunches the Air Max by rereleasing the first model.

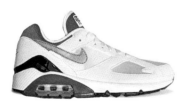

AIR MAX 180
180 degree air bubble

AIR MAX 95
First reveal of the front air bubble

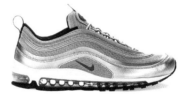

AIR MAX 97
Air bubble all along the sole

The bright red color was also inspired by the Centre Pompidou.

With its window revealing the secret of its famous sole, the Air Max proved that design and technology can make good bedfellows.

In 1986, designer Tinker Hatfield—father of the Nike Air Jordan —visited Paris's Centre Pompidou for the first time. He was struck by the museum's dramatic design, where escalators and air ducts are placed on the outside of the building—the former running through transparent tubes, and the latter painted in bright colors—to free up space inside. This gave him the fantastic idea of making visible the shock-absorption system—dubbed "Air"—which the general public was having trouble understanding. So on March 26, 1987, the first Air Max—in red and white—was released; its thin transparent plastic tube beneath the heel was a window onto a world of technology that had hitherto been abstract. But more than that, it was a serious disruption to the sneaker world. Long prophesized, the Nike Air wonder came to pass, and has endured, through dozens of variations that have gone down in the annals of design. In 2006, the Nike designers' old dream of a wholly transparent sole was realized with the Air Max 360. The innovative Air Max was first adopted by the hip-hop youth of the 1990s and 2000s, followed by fashionistas in 2013, who were inspired by the end of a Phoebe Philo fashion show, when the designer strode down the catwalk in a pair of Air Max OGs before a flabbergasted front row.

180

The name of the Air Max model released in 1991, which revealed 180 degrees of the shock-absorbing midsole.

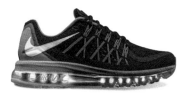

AIR MAX 2015
The reinvention

AIR MAX TN
Alias The Shark

AIR MAX SKYLINE
Maximum power

THIS IS A REVOLUTION

The sole is the key part of a sports shoe.
Here is a look at the most famous inventions.

1917
RUBBER
CONVERSE
The first great technological revolution in the sports industry helped basketball players avoid slipping on the court.

1946
[1] AERATION SYSTEM
SPRING COURT
Ten years after the invention of the G1—the first shoe designed especially for playing tennis, and featuring a glued rubber sole —Spring Court drilled eight holes in it to ventilate the foot and also added a removable insole.

1974
WAFFLE
NIKE
Bill Bowerman, the Nike cofounder, conceived this gripping sole, which would boost athletic performance and forever change the design of future sneakers.

One day, at the peak of his glory, Michael Jordan explained that his performances on the NBA courts depended not on the quality of his shoes, but what he himself did with them. That's one way of deciding an ongoing debate: where do the true benefits of a technological innovation start and end? It's a question that sports outfitters have been wrangling with since the early 1990s. At the heart of this industry battle lies the sole, the focus of most research and development—the major brands work at improving its flexibility, its power, and its shock-absorbing qualities. Skeptics see this as just a load of marketing hokum, even a con. Such is the view of devotees of the barefoot running movement, backed by Harvard University, who blame super shock-absorbing shoes for impairing our natural stride (striking the ground with the forefoot) by encouraging us to strike the ground with the heel first. It's a difficult one to call, particularly since a sports podiatrist would insist on the importance of antivibration shoes. And manufacturers continue to introduce one innovation after another. Not a year goes by without a new and "revolutionary" concept hitting the running department of sports shops. It's an old, and lucrative, business.

1

1975
EVA FOAM
BROOKS

Ethylene-vinyl acetate (more commonly known as foam rubber) went on sale in 1950. The material is light, flexible, and shock absorbing, and was employed for the first time by the American Brooks brand, which specializes in running shoes.

1979
[2] AIR SYSTEM
NIKE

Paired with EVA, the famous air cushion placed in the sole of the Tailwind offered greater comfort. An invisible system that the general public had some difficulty understanding until the introduction of the famous window on the Air Max, in 1987.

1980
FEDERBEIN CLEAT
PUMA

The V-shaped rubber Federbein cleat provided better grip and improved shock absorption.

2

3

1987
GEL
ASICS

In use since 1986, the Gel ASICS concept uses silicone, and turns the shockwave generated by the foot's impact on the ground into positive energy.

1987
[3] HONEYCOMB
REEBOK

Hexalite, the commercial name for this honeycomb structure, is a shock-absorption system placed beneath the heel and the forefoot that the user can regulate via a pump system. In 1990, it had become four times more effective than EVA.

1988
TORSION BAR
ADIDAS

The (yellow) bar placed beneath the sole provided an improved transition of energy between the heel and the forefoot, as well as greater stability.

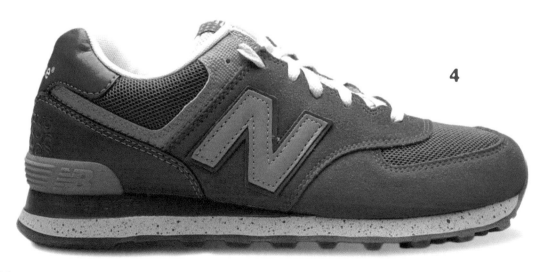

4

5

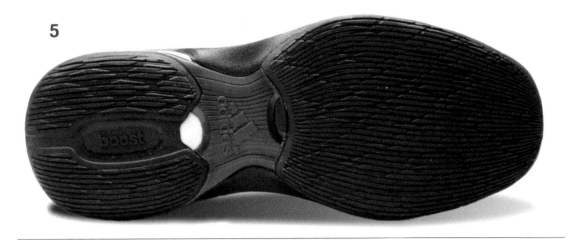

1988
[4] SLIPPER
NEW BALANCE
Comprising a polyurethane envelope and an EVA core, the Encap® guaranteed the unique sensation of wearing slippers far from one's lounge.

2000
SHOCK-ABSORBING TUBES
NIKE
The Shox system of shock-absorbing tubes was the fruit of fifteen years of research, and was directly inspired by the Cadillac. It provides a degree of "spring back," using the energy released as the foot presses down.

2012
[5] BOOST
ADIDAS
Composed of a cluster of microcapsules and the result of a new chemical process developed with BASF, the Boost sole maintains the same degree of grip from – 4°F to 104° F. It absorbs shocks while returning the energy of the impact, for a self-generated energy boost as the foot strikes the ground.

5

NIKE AIR MAX

90 BLACK

MOIRE

3.26

93 JADE STONE DARK DUNE

90 ULTRA

1 CAMO - BERLIN

1 SUP QS "TROPHY"

DQM X NIKE AIR MAX 90 "BACON"

TAPE (WOMEN)

THEA

TAPE (MEN)

1 EM "BEACHES OF RIO"

REFLECT COLLECTION

180

90 GS HYPER GRAPE PURPLE PINK

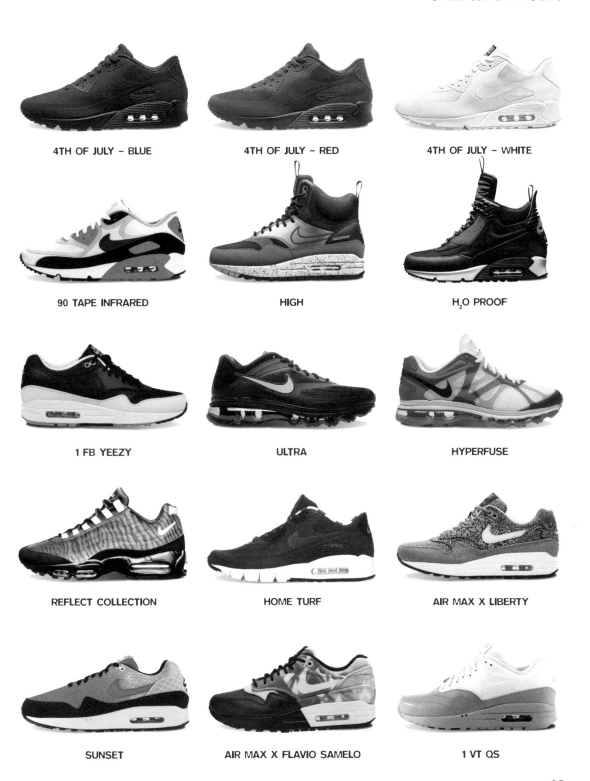

4TH OF JULY – BLUE

4TH OF JULY – RED

4TH OF JULY – WHITE

90 TAPE INFRARED

HIGH

H$_2$O PROOF

1 FB YEEZY

ULTRA

HYPERFUSE

REFLECT COLLECTION

HOME TURF

AIR MAX X LIBERTY

SUNSET

AIR MAX X FLAVIO SAMELO

1 VT QS

THE REBEL LABEL

LOW
Urban cool

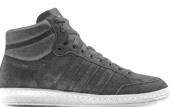

SUEDE
Soft and daring

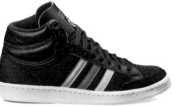

BLACK
Reggae style

Basketball's grand aristocrat ended up slumming it at rock concerts and on electro dance floors.

The Adidas Americana Hi 88 was developed for the American Basketball Association in 1971, and it bears the red and blue colors of this professional league, which merged with the NBA in 1976. Basketball fans were mad for the shoe, with its canvas upper (switched to leather in 1975) and that sublime logo on the tongue. A decade later, its younger sister, the Superstar, would be a big hit on the hip-hop scene, but the Americana found other musical families to adopt it: hard rock—metalheads liked to wear it with their spandex pants and fishnet vest tops—and disco, particularly on roller dance floors, with a four-wheeled skate buckled to each shoe. The Americana is one of those sneakers that wears and ages well, taking just a few months to go from immaculate freshness to truly scuffed, without losing any of its cool. The shoe has been rereleased sparingly since the late 2000s, and is now one of the favorites of French house electronic artists, such as Pedro Winter and Justice, as well as being a hit with graphic designers in Paris and Berlin.

15
MINUTES

The time it took in 2009 to sell the one hundred Americana pairs redesigned by the French agency BKRW.

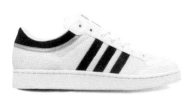

BLUE AND GOLD
Elegance

METALLIC
2014 rerelease

AMERICANA VULC
Skateboard style

LE COQ SPORTIF ARTHUR ASHE

PURE CHIC

1983
Launch of the Noah Comp,
with a profile similar to that
of the Arthur Ashe.

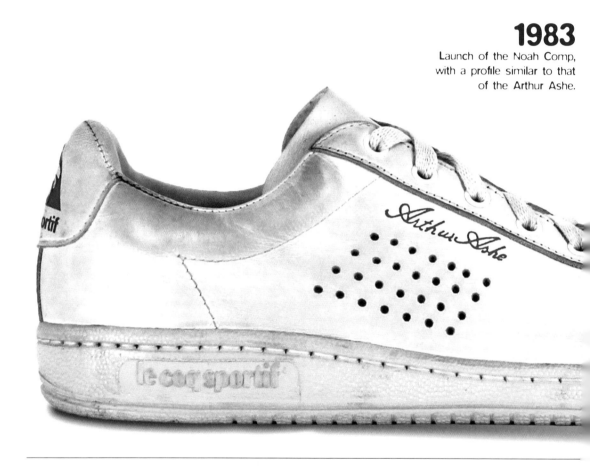

MADE IN FRANCE
Refined

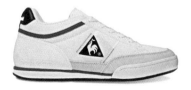

NOAH COMP
Little sister

PREMIUM
Quite chic

Fifty-five pairs of a woven blue and white leather model were made.

The shoe is a perfect reflection of its American tennis player owner: elegant, smooth, and understated.

On Saturday July, 5 1975, the very classy African-American tennis player Arthur Ashe won Wimbledon, his third and last Grand Slam title, beating his compatriot Jimmy Connors. He wore a pair of immensely elegant shoes; the white leather, minimalist design, sleek lines, and perforations on the side evoked the already popular Adidas Stan Smith. They were twins of diametrically opposed design. Thirty years later, the shoe of the mustachioed dandy still outsells that of Yannick Noah's mentor, but this commercial success has always lacked something that anyone would consider to be essential: a touch of soul, that of Arthur Ashe, an aesthete of the game inspired by noble causes (the fight against segregation, poverty, and AIDS—of which he died in 1993) like nobody else in the history of the sport. And these days, the Arthur Ashe shoe is a rarer beast. It sells less, but has gone upmarket. One example is the all-white Made in France model from 2015: a limited edition of just 136 in full-grain leather from the Roux tanneries—who supply haute couture houses—and entirely produced in the workshops of Romans-sur-Isère in southeastern France, the capital of the luxury shoe industry.

235

The price in dollars of the Arthur Ashe 2015 rerelease.

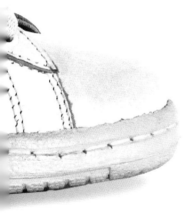

COLETTE
Very limited collaborative edition

CRAFTED SUEDE
Man about town

PYTHON
Top design

ARTHUR ASHE

THE INCARNATION OF STYLE

A fair and elegant player and a promoter of major causes, Arthur Ashe wore a sports shoe that was his very reflection: simple and stylish.

Arthur Ashe was a chic man, in every sense of the word. A fluid and refined tennis player throughout his career, which stretched from 1968 to 1980, the American left the impression of calm and perfect self-control upon every court where he played. And this class translated quite naturally off court, notably in the way he dressed. "Arthur had unbelievable style, quite a cut above the rest," recalls Yannick Noah, the French tennis legend whom the American champion took under his wing in February 1972, after having exchanged a few rallies with him during a tour to Yaoundé, in Cameroon. "I don't know how he did it, but he always had a different look. Everything suited him, from that long fur coat to the most improbable checked shirt. But what I remember most about him was his incredible kindness." The talented and elegant Arthur Ashe was also one of those men blessed with great magnanimity. The four-times Davis Cup winner and three-times Grand Slam champion also campaigned on behalf of black people in South Africa, under apartheid, and fought against repressive measures aimed at Haitian refugees to the United States. He was also one of the first celebrities to support research into AIDS. He himself had contracted HIV from a blood transfusion, and he died of pneumonia on February 6, 1993, aged forty-nine.

Arthur Ashe, in 1969.
A class act, to whom
Le coq sportif pays
homage with the model
that bears his name.

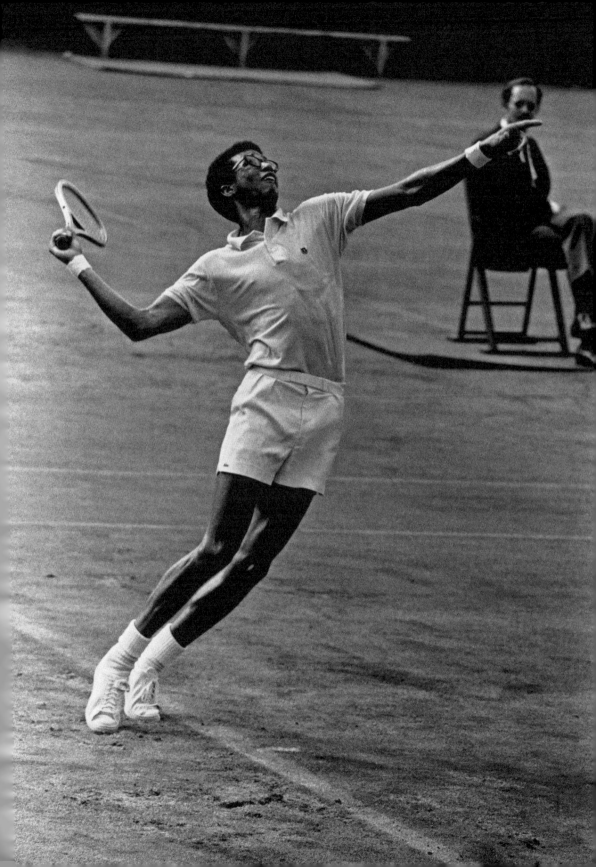

SCIENCE IN MOTION

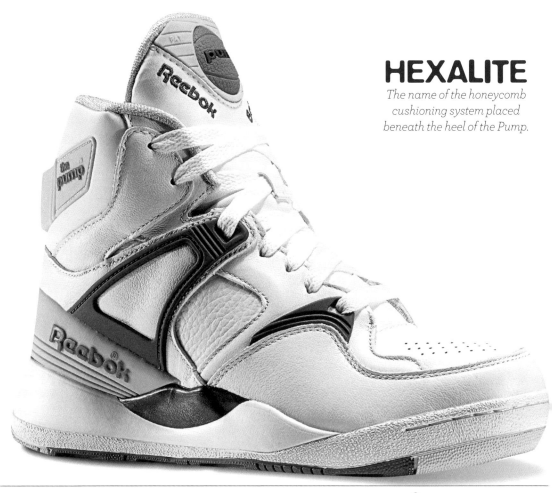

HEXALITE

The name of the honeycomb cushioning system placed beneath the heel of the Pump.

BRINGBACK
The historic model

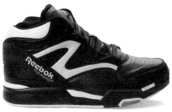

OMNI LITE DEE BROWN
Slam dunk star

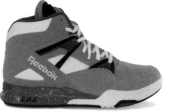

OMNI ZONE
Most popular

February 9,
1991
The Pump's first leap to glory, thanks to the victory of Dee Brown, guard for the Boston Celtics, in the NBA Slam Dunk Contest at the All-Star Game.

The British brand's technology took a long time to convince people, until it was saved by a few crazy NBA slam dunkers.

Everyone chortled at first. The idea of working a pump located in the tongue of a shoe to inflate an air cushion that would hug the shape of one's foot seemed as ridiculous as it was far-fetched. Launched in 1989, at the height of the mad dash of technological innovation in the sneaker business (Nike Air, Adidas Torsion, and Puma Disc), Reebok's Pump system, which the general public had some difficulty understanding, went on sale at the eye-watering price of $170. The prospects weren't good. And sales only started to rise after a few months, thanks to the crazy NBA slam dunker Dominique Wilkins,

26

The number of Pump models created since 1989.

who converted a whole generation to the little orange basketball-shaped pump. In 1991, the concept was adapted for tennis with the Court Victory of Michael Chang—winner of the French Open two years earlier, and the only player able to compete with Andre Agassi, whose Nike Air Tech Challenge shoes could be found scampering across schoolyards everywhere. Reebok has always remembered this cult item at the back of its closet, and in 2009 it rereleased it in a special twentieth-anniversary edition. The Pump continues to arouse emotion, and some nostalgia, in those who were kids in the 1980s.

INSTA PUMP FURY OG
Weirdest

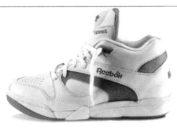

COURT VICTORY OG
Michael Chang

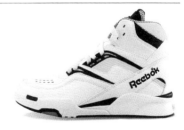

TWILIGHT ZONE
Biggest

REEBOK PUMP

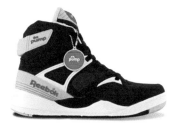

REEBOK PUMP X ATMOS

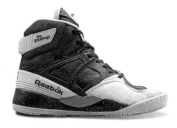

PUMP 25TH ANNIVERSARY
X BODEGA

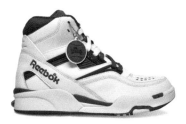

TWILIGHT ZONE
DOMINIQUE WILKINS

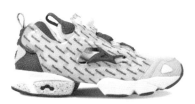

PUMP FURY X GARBSTORE

PUMP FURY X CONCEPTS

PUMP FURY X ATMOS

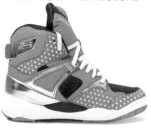

REEBOK PUMP X MAJOR DC

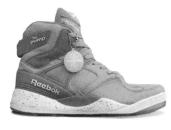

PUMP 25TH ANNIVERSARY X
MITA SNEAKERS

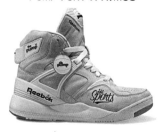

REEBOK PUMP X ARC SPORTS

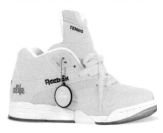

PUMP COURT VICTORY
X ALIFE

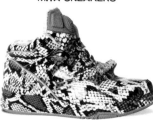

PUMP OMNI LITE X MELODY

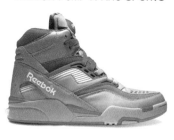

PUMP TWILIGHT ZONE

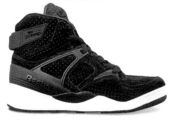

PUMP 25TH ANNIVERSARY
SNEAKERSNSTUFF X PUMP

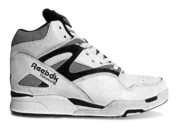

OMNI ZONE 2

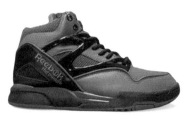

OMNI LITE DEADPOOL X MARVEL

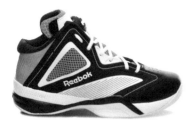

PUMP REVENGE

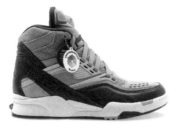

TWILIGHT ZONE PUNSCHROLLS

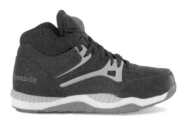

PUMP AXT

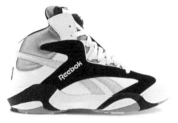

SHAQ ATTAQ

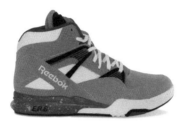

ERS

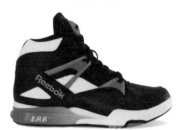

ERS

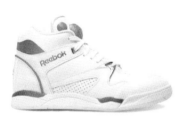

AEROBIC

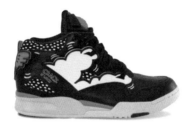

OMNI LITE KEITH HARING

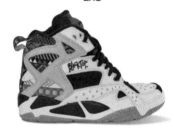

BLACKTOP BATTLE GROUND

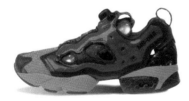

REEBOK PUMP FURY X GUNDAM

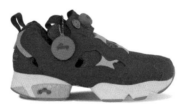

PUMP FURY BLUE

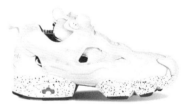

PUMP FURY X SANDRO

REEBOK PUMP X LA MJC X
COLETTE

PAYDIRT

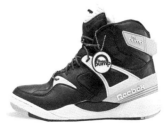

PUMP 20TH ANNIVERSARY X
SOLEBOX

FILA FITNESS

THE ITALIAN JOB

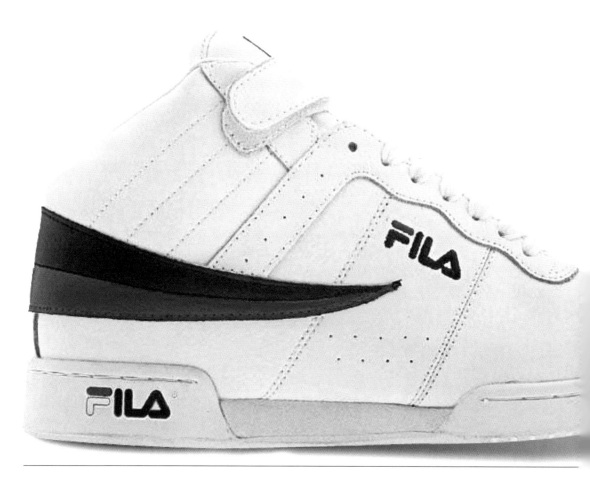

FITNESS LOW
Low-top style

PEACH STATE
Homage to Georgia

FITNESS RED
The must-have

This Italian answer to the Reebok Freestyle stole some of the British icon's limelight in the late 1980s.

Fifteen years after its triumphal arrival in the world of sportswear —marked by the exploits of the Swedish tennis player Björn Borg—the Italian clothing firm Fila, founded in Biella in 1911, took advantage of the 1980s fitness boom to launch its first sneaker, appropriately called the Fitness, in 1988. With its streamlined look, tiny aeration holes on the front of the foot, and ankle strap, the Fila Fitness looked like a cross between the Reebok Freestyle—a fixture of gyms and aerobics studios—and the Ex-O-Fit, the Freestyle's counterpart for men, launched in 1987. Despite the obvious plagiarism, the charm and finesse of the Fila Fitness made it a great success (although it never reached the heights of popularity of Reebok's cult models), assisted by Fresh Gordon, the ambassador of cool whose track "My Fila" was a hit. The white model with navy blue sole would be Fila's best seller, while the all-orange version became a must-have item all over Europe. In 1990, its design would serve as the basis for the Hiker, designed to do exactly as its name suggests.

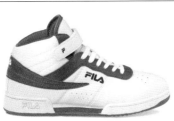

F13
New generation

PEACH STATE
Name of the Fitness model designed by the Fly Kix store in Atlanta, Georgia, in homage to the state's top-quality fruit.

F13
The Fitness's new name when it was rereleased in 2003.

POP-ROCK PUMP

1946
Side aeration holes
are added to the G1.

G2 SUÈDE
Fashion variant

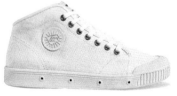

B2
Little sister

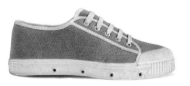

VINTAGE JEAN
Pretty cool

The G2 (lower sole) and the B1 (high-top) are the heirs to the G1.

John Lennon's favorite shoe left the tennis courts in the mid-1960s and became an emblem of French chic.

In 1936, French tennis fan Georges Grimmeisen, the son of a cooper, invented a shoe with a rubber sole to improve the players' movements across the court. With its white canvas, cotton upper, four side holes, and glued rubber sole, the G1 became a key sportswear item until the mid-1960s. In Paris, in May 1968, it could be spotted on the feet of angry students. Serge Gainsbourg made a commercial for them in 1968, and Jane Birkin trudged about in the sludge in a pair. But it was a year later that the shoe achieved global fame, when John Lennon wore them on the cover of the album *Abbey Road*, as well as for his wedding to Yoko Ono. One million pairs were sold during the 1960s. In the 1970s, the G1 was overtaken by the new generation of leather tennis shoes, and gradually disappeared before being relaunched in the early 1990s, when it was bought by the classy brand Rautureau—which diversified the materials, the formats, and the colors. In the early 2000s, the G2 became a key, yet discreet, cornerstone of casual chic, worn by the likes of Johnny Depp, Vanessa Paradis, and Jude Law. This springtime shoe is a great alternative to the espadrille, and is worn without socks. And if you're a purist, only the low-top white version will do.

200,000

The number of G2 pairs produced each year.

COLLEGE VICHY
Pretty chic

LEATHER
Pretty sturdy

**SPRINGCOURT
X COMME DES GARÇONS**
Pretty daring

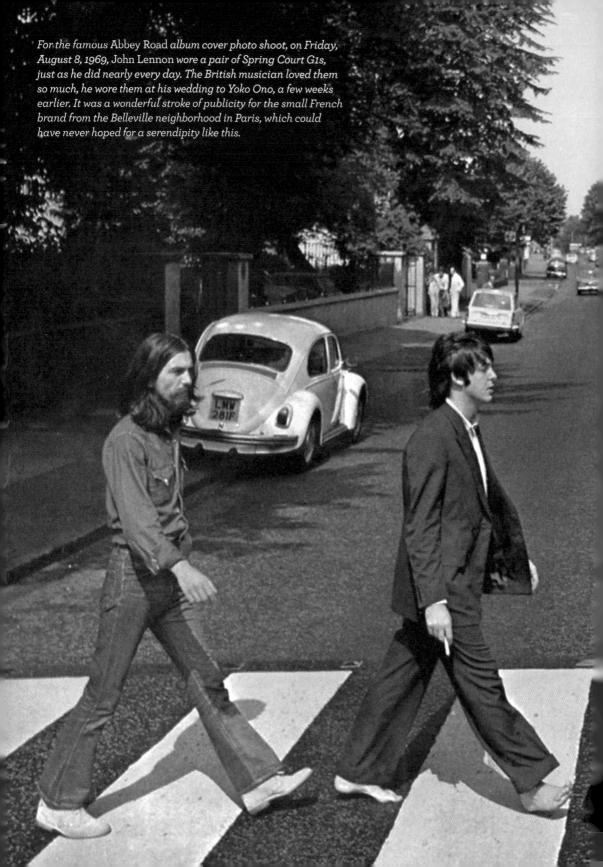

For the famous Abbey Road album cover photo shoot, on Friday, August 8, 1969, John Lennon wore a pair of Spring Court G1s, just as he did nearly every day. The British musician loved them so much, he wore them at his wedding to Yoko Ono, a few weeks earlier. It was a wonderful stroke of publicity for the small French brand from the Belleville neighborhood in Paris, which could have never hoped for a serendipity like this.

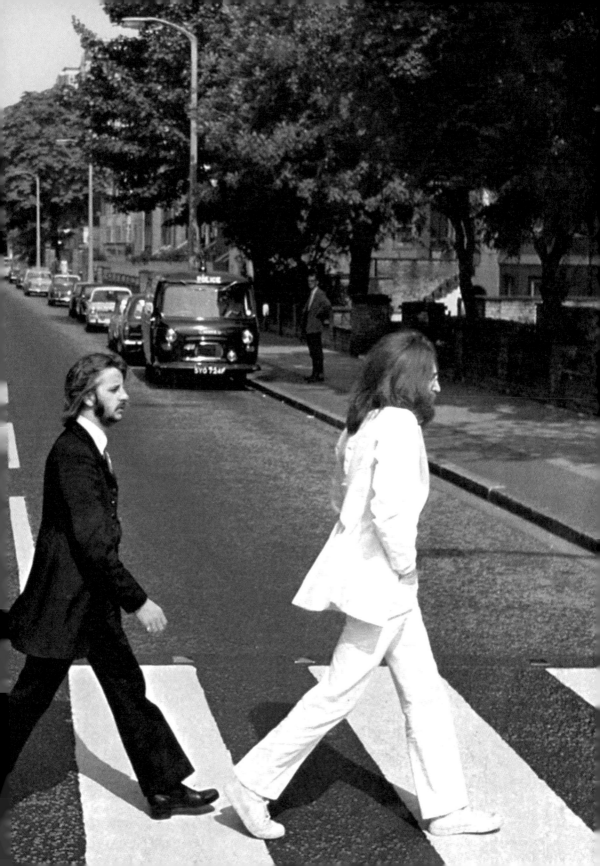

THE EVER-FASHIONABLE OLD-TIMER

1966
Appearance of the Oxford, the low-top version of the All Star.

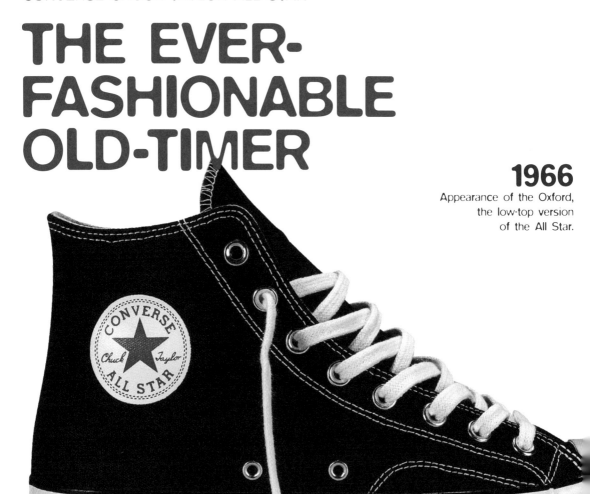

ALL STAR 1917
The first Converse

ALL STAR 1928
The All Star before Chuck Taylor

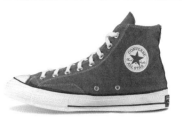

CHUCK TAYLOR ALL STAR 1971
The Chuck takes off

The basic DNA of the All Star has not changed since 1949.

This basketball shoe is the oldest sneaker still around today, having sold over 800 million pairs since 1917. A universal charm against bad style.

Designed by a specialist brand of boots and shoes for construction workers that had sensed the rise of basketball in the United States, the Converse All Star owes much to its ambassador, the salesman Chuck Taylor. Since 1932, his signature has adorned the famous star badge that he designed a few years earlier to protect the inner malleolus (the protruding part of the ankle bone) of these giants with feet of clay. "Chucks" or "Converse" were a mainstay of footwear for NBA stars, such as Magic Johnson and Larry Bird until the 1970s, and were a popular fashion item as far back as the 1950s, worn by cool students at California universities and workers at General Motors. With the advent of rock and roll, the All Star, worn with a black leather jacket and a pair of jeans, slowly began to outgrow its "sports" label. This stiff shoe, which can be pretty difficult to put on the first time until it slowly molds to the shape of one's foot, became popular with skateboarders and BMX riders in the 1980s, and then with musicians, such as Kurt Cobain, Iggy Pop, and Snoop Dogg, ten years later. The shoe has featured on the movie screen many times, and even traveled back in time when a pair of powder blue high-top Converse made a brief appearance in Sofia Coppola's *Marie Antoinette* (2006), in a scene where the young queen (Kirsten Dunst) is shown trying on numerous pairs of shoes—the incongruity doubtless intended to subtly suggest a certain teenage spirit.

60%

of Americans own, or have owned, at least one pair of All Stars at some point in their lives.

CHUCK TAYLOR ALL STAR RUBBER
100 percent rubber

CHUCK TAYLOR DISTRESSED FLAG
American emblem

CHUCK TAYLOR ALL STAR ANDY WARHOL
Arty low-top

THE MOST FAMOUS TRAVELING SALESMAN IN THE WORLD

The global success of the Converse All Star is mainly due to the passion and effort of its best ambassador, who lived only to popularize this sneaker and the sport he loved so much.

The story of Charles Hollis Taylor is that of a cheeky twenty-year-old student who, in 1921, knocked on the doors of the Converse company in Chicago, and suggested nothing less than perfecting the All Star, a 1917 model that this basketball player had been wearing on the courts since his high school years in Columbus, Indiana. Chuck was hired on the spot and modified the shoe in just a few months, notably by adding the leather patch that serves to protect a player's inner malleolus (the protruding part of the ankle bone). Convinced of basketball's appeal to American youth and of the performances made possible thanks to the All Star (which bore his name from 1932), Chuck Taylor invented a new career for himself, that of super-salesman-evangelist for his sport—and, of course, his sneaker. He crisscrossed the US in his white Cadillac, the trunk filled with shoes, and held training sessions, or "concept clinics"—an entirely novel idea—in high schools and universities.. He moved from one motel to the next, with no other pied-à-terre than his office at Converse HQ, and very soon became a key personality in American basketball. "It was impossible not to love Chuck," recalled Joe Dean, head of sales at Converse for thirty years, in conversation with the *Philadelphia Inquirer*. "If you were a coach and were looking for a job, you had to call Chuck. And team managers talked to him when they needed a coach." A consultant to the US military during World War II—the All Star became the official sneaker of the US armed forces—Chuck Taylor continued his mission until 1968, the year of his retirement. But he wouldn't have much time to enjoy it, as he died of a heart attack on June 23, 1969. Nearly a century later, Chuck Taylor joins Michael Jordan and Stan Smith in that elite group of famous names to grace a sneaker, one that will, without a doubt, never die.

Chuck Taylor wore the colors of the professional basketball team the Akron Firestone Non-Skids, based in Akron, Ohio, before spending the rest of his life promoting the Converse brand, of which he was their best ambassador and greatest fan.

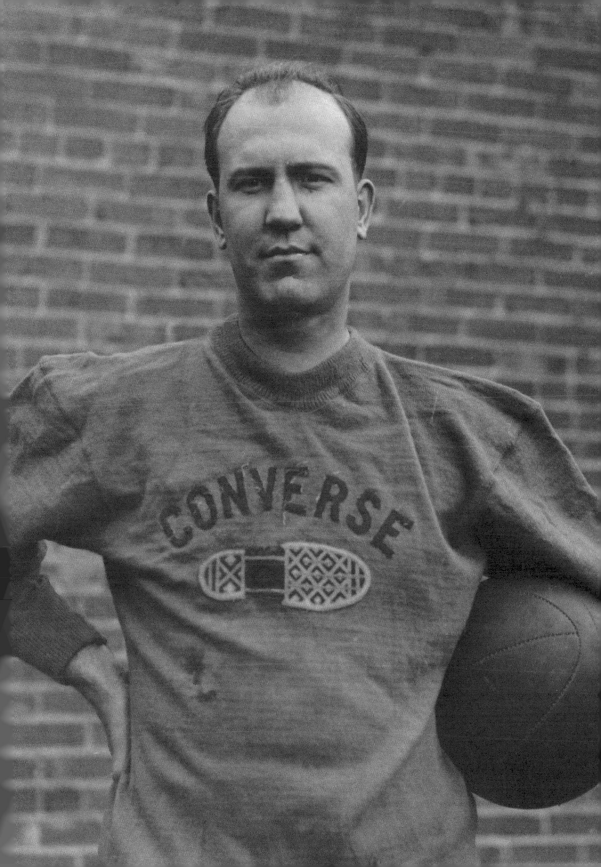

CONVERSE CHUCK TAYLOR ALL STAR

1950S

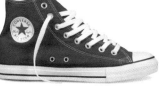

1971 – RED

2000

ANDY WARHOL

CAMOUFLAGE GREEN

CITY HIKER

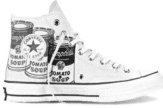

COMBAT BOOT

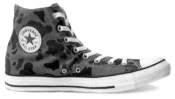

CHUCK TAYLOR X DC COMICS -
SUPERMAN

DENIM

DOWN JACKET

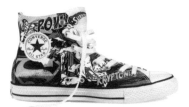

FLORAL

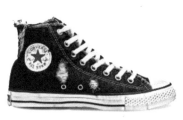

FRESH COLORS

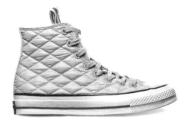

ANDY WARHOL

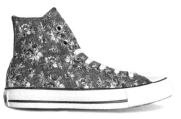

KNEE

CHUCK TAYLOR X
SNEAKERSNSTUFF - LOVIKKA

LOW

MINI BUFFALO PLAID

CHUCK TAYLOR X AC/DC

MULTIPANEL

MULTICOLOR WEAVE

THE SIMPSONS

PLATFORM PLUS

PLATFORM

PREMIUM

WINTERIZED COLLECTION

SARGENT

SUEDE

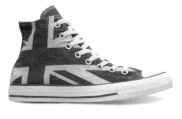

UNION JACK

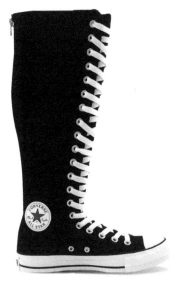

XX HIGH

ADIDAS SL 72 & SL 76

STARSKY'S SNEAKER

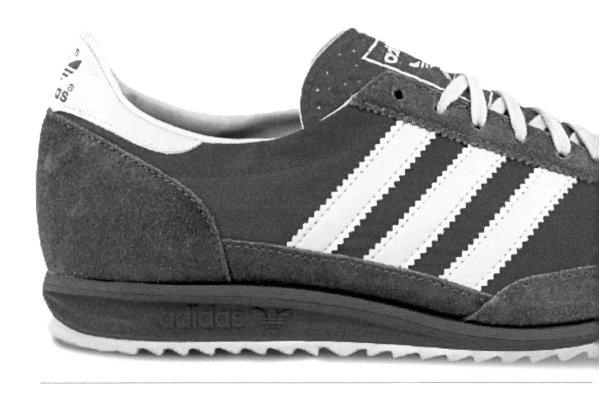

SL 72 MUNICH
The legend

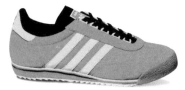

SL 76
Passing of the baton

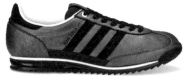

HAN SOLO 77
Star Wars style

Designed for runners at the 1972 Summer Olympics, the Super Light owes its fame to the TV series *Starsky & Hutch*.

HAN SOLO

In 2010, Adidas brought out a version of the SL 72 in homage to the daring pilot of the Millennium Falcon in the Star Wars *films.*

The Super Light, with its tapered upper made of nylon, leather, or suede, made its first appearance on the podiums of the Munich Olympics in 1972, before going on to wow the weekend joggers. In 1975, it broke out of the stadium, running down the streets of the fictional Bay City—and sliding across car hoods—on the feet of David Starsky, the curly-haired, jean-wearing, mischievous cop from the TV series *Starsky & Hutch*. The irrefutable proof of the shoe's power was the suggestion that without them, this daring duo would never have been able to arrest all those bad guys. The actor Paul Michael Glaser wore various versions of the SL, notably the 76—which has beefier lines. The shoe of the Montreal Olympics is, today, one of the most highly sought-after sneakers in the world, with collectors particularly eager to get their hands on those now extremely rare pairs stamped "Made in West Germany." Fans of the series make do with a pair of Dragons or Achills, which the fearless detective also wore. Rereleased in 2004 and 2011, the SL 72 was used as a reference for the design of the Boost running shoes, which were launched in 2013.

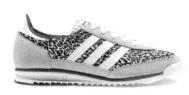

SL 72 LEOPARD
Fast fashion

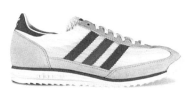

SL 72 WHITE
2010 rerelease

SL LOOP RUNNER
The descendant

A FIGHTER JET

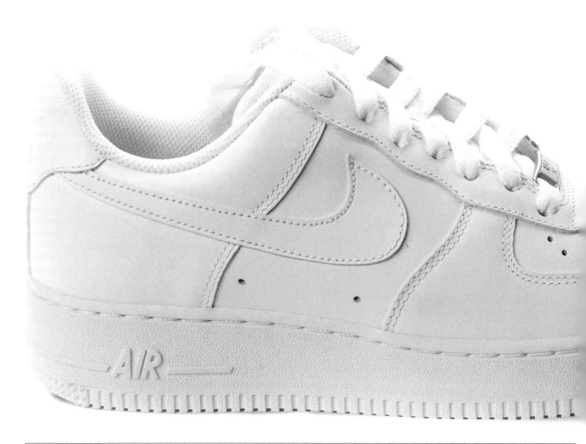

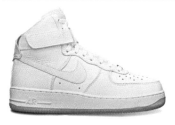

AF 1 HIGH

High-top

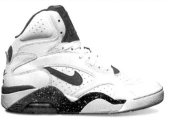

AF 180

Current heir

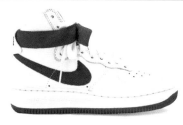

AF 1 CHINA "NAI KE"

Homage

VELCRO

The Velcro tongue that fastens around the front of the ankle on the high-top model is called the proprioceptus belt.

With its combination of power and refinement, this shoe was produced in nearly 2,000 versions. A block of pure elegance.

In 1990s New York, the youth of Harlem made this 1982 sneaker their emblem—calling it the "uptown." There were five basic models and nearly 2,000 versions, from low-top to mid-top to high-top. Today, the Air Force 1 is one of the best-selling shoes in the world, partly thanks to such luxury ambassadors as Jay-Z, who, it is said, always wears a new pair in order to preserve the dazzling whiteness, and the rapper Nelly, who celebrated his favorite kicks in a song called "Air Force Ones" in 2002. This sneaker is now a fixture of popular culture and a guarantee of good taste. Tough yet elegant, powerful yet light, this was Nike's first shoe to have an air sole, and is one of those very rare sneakers you can wear with a suit without looking out of place —but only a black suit, for contrast, and only if the pair you're wearing is perfectly white. The detail that makes a difference is the deubré —that ornamental metal shoelace tag centered between the first pair of eyelets closest to the toe.

800
MILLION
DOLLARS

The annual revenue from sales of the Nike Air Force 1.

AF 1 X MARK SMITH
The rarest

AF 1 X MR CARTOON
Impossible to find

AF1 – THE DEUBRÉ
The ornament

NIKE AIR FORCE 1

CRESCENT CITY

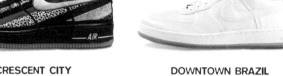

DOWNTOWN BRAZIL

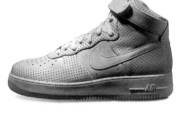

SUPREME TZ

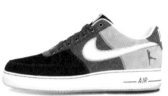

DIRK NOWITZKI

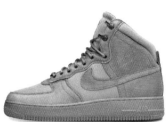

XXX SFB

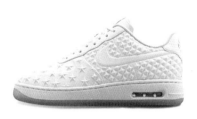

CONSTELLATION

DOWNTOWN HI

AIRNESS

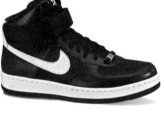

WEATHERMAN

DOWNTOWN

AJF 6 (AF 1 + AJ 6)

LONDON OLYMPICS 2012

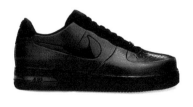

FOAMPOSITE

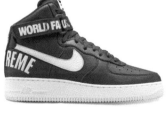

AF 1 X SUPREME

ANACONDA

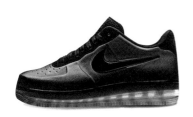

FOAMPOSITE MAX "BLACK FRIDAY"

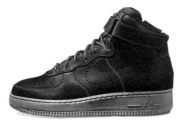

SUPREME HI QS

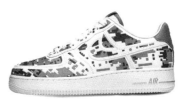

XXX CAMO DIGITAL

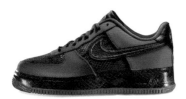

LOW COMFORT

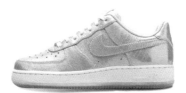

IRIDESCENT

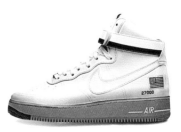

XXX PRESIDENTIAL EDITION

EASTER PACK

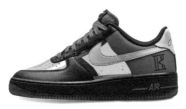

KYRIE IRVING

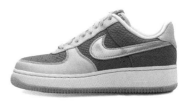

YEAR OF THE DRAGON

DOWNTOWN 1 SPIKE

DUCKBOOT

PATINA - PAULUS BOLTEN

PLAYSTATION

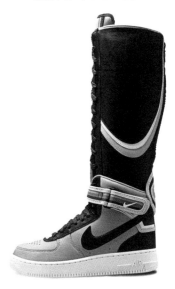

AF 1 X RICCARDO TISCI - BOOTS

REEBOK CLASSIC LEATHER

A CHIC, POPULAR SHOE

1987

Launch of the Classic Nylon, with a nylon and suede upper.

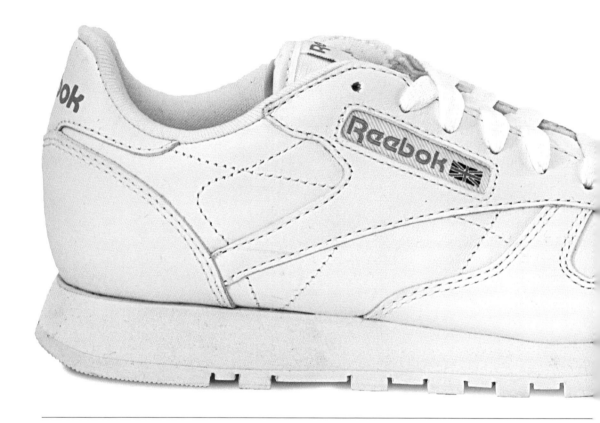

CLASSIC LEATHER BLACK
Historic

CLASSIC LEATHER NYLON
Most comfortable

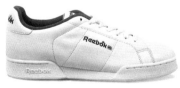

NEWPORT CLASSIC
Most elegant

NEWPORT

This tennis version of the Classic, launched in 1989, was popularized by Mike Skinner, the singer of The Streets, in the 2000s.

This basic of British fashion is the United Kingdom's most popular sneaker of all time.

Launched in 1983, partly to counter the success of Nike's Cortez, the Classic Leather was Reebok's second great success after the Freestyle. Less technical and less sophisticated than its other running-shoe rivals, this plain, comfortable sneaker was an easy addition to the casual wardrobe, and the pride of Britain, with the national flag embroidered on the upper. The Classic Leather was a hit with Sunday gents, celebrities, pop singers, hip-hop artists, soccer fans, and pub regulars—the last two, it must be said, were often the same. And in a similar fashion to the Cortez in the United States, they were also the burglars' favorite. In a study of shoe prints at one hundred burglary sites in Northamptonshire, United Kingdom, carried out by researchers from the University of Leicester and published in *Police Review* magazine in 2010, it was found that 52 percent of them came from a Classic Leather sole. Why this particular model? Because they are the "softest and lightest," according to one policeman: "Burglars are not stupid; they pick the softest and lightest trainer when they go on a job so nobody will hear them."

TRAVI$ SCOTT

In 2013, the twenty-two-year-old American rapper was chosen as brand ambassador for the Classic.

CLASSIC X BURN RUBBER
Homage to Detroit

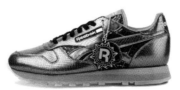

30TH ANNIVERSARY
Limited edition

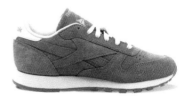

EXOTICS
On trend

THE ICON DECLARED MISSING

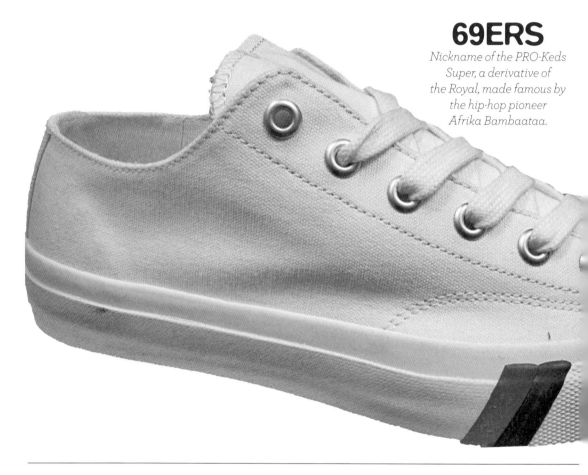

69ERS

Nickname of the PRO-Keds Super, a derivative of the Royal, made famous by the hip-hop pioneer Afrika Bambaataa.

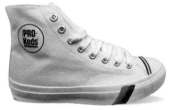

ROYAL CANVAS HI
High-top version

ROYAL EDGE
Play Cloths version

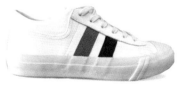

ROYAL PLUS
Sturdier

"SURESHOT"

*The original name
of the PRO-Keds Royal*

A star of the NBA in the 1950s and 1960s, this icon of New York street culture was one of the most adored sneakers in Japan.

A sneaker legend died on February 3, 2014. That was the day the American brand Keds announced it was stopping production of the PRO-Keds sports line, burying with it the Royal—an icon of basketball, and later street culture, born in 1949. In the 1950s, the renown of this canvas shoe—recognizable by the two red and blue stripes toward the front edge of the sole—grew with the exploits of the giant George Mikan (6 feet 10 inches tall), star of the young NBA and hero of the Minneapolis Lakers, who won the championship five times between 1949 and 1954. This classic of the courts, and a major rival to the Converse All Star, became the Royal Master (or Royal Plus) in 1971. It had a suede upper, which made it sturdier, and a cushioned ankle cuff, for comfort, while the two stripes were shifted to the upper and made wider. This new model became a must-have accessory for the nascent New York break dancing scene —as did its brand mate, the Pony Top Star. Before disappearing in 1986, Keds brought out the Royal Edge (or CVO), which was a big hit with skateboarders, since its design was very close to that of the Vans Authentic. Extremely popular in Japan, the brand was reborn in 2002 with the relaunch of its flagship model, which it would abandon twelve years later. One of the last redesigns came in October 2009, courtesy of DJ Bobbito Garcia, author of the cult book *Where'd You Get Those? New York City's Sneaker Culture 1960–1987*. Now the Royal is but a rare find in certain niche stores.

200

The number of pairs of the Royal CVO produced in collaboration with the beer brand Pabst Blue Ribbon, who gave the shoes to a few hip celebrities.

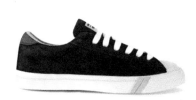

ROYAL MASTER
Suede upper

ROYAL
Redesigned by Patta

PRO-KEDS X BOBBITO GARCIA
The sneaker expert's model

VANS AUTHENTIC

SKATEBOARDER'S DELIGHT

$2.49

The price of the Authentic in 1966. It now costs fifteen times that amount.

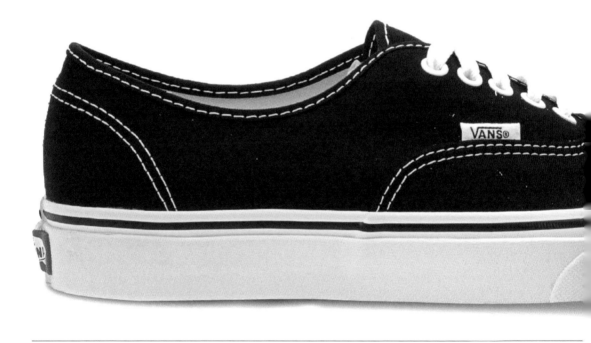

ERA
Twin sister

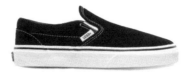

SLIP-ON
Laceless best seller

SLIM VAN DOREN
The homage

From Hollywood to New York, the Vans Authentic is regularly seen on the feet of stars such as Zac Efron, Chris Brown, Rihanna, and Lil Wayne.

The first shoe designed exclusively for skateboarding is still here, fifty years later, now available in a wide range of versions.

The Van Doren brothers opened their first store on March 16, 1966, after having moved to Anaheim, California just a few months before. That morning, they never imagined that a dozen customers would come walking through the door of 704 East Broadway to buy a pair of Authentics. But there was a problem; the founders of this brand aimed exclusively at the skateboarding market only had a few display models—the boxes lining the walls were, in fact, all empty. So they asked their future buyers to return that afternoon, then rushed back to the factory to make the required shoes. Thus began the amazing story of the very first skateboarding shoe—made of canvas, with narrow stitching and a thick white rubber sole with a waffle tread to better grip the skateboard. Ten years later, Vans launched the Era, an almost identical model with a cushioned ankle cuff. Next came the laceless Slip-On—designed for BMX bikers—which became an icon of street culture, beloved by all true sneaker fans for sunny days.

$300

The relatively low cost of the endorsement deal between Vans and Stacy Peralta, the star skateboarder of the 1970s and 1980s, who wore the Era.

ROBERT CRUMB X VANS VAULT
Underground

MIKE HILL X VANS SYNDICATE
Sleek

EDITION 2015
Audacious

VANS AUTHENTIC

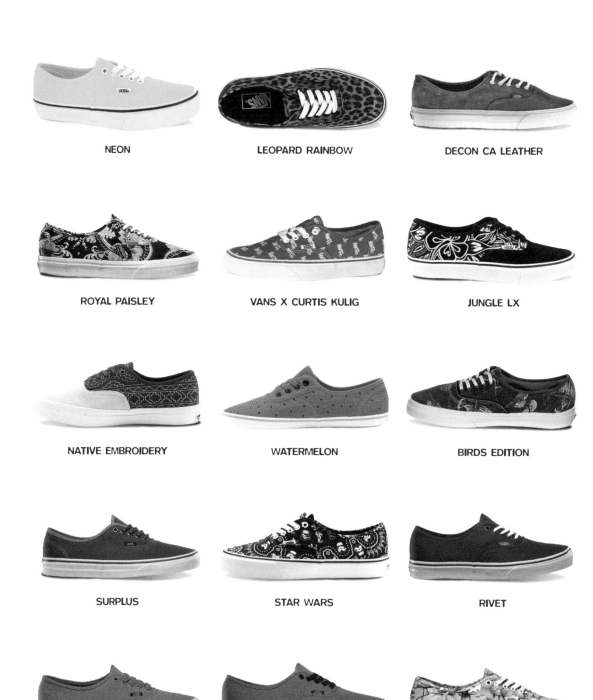

NEON

LEOPARD RAINBOW

DECON CA LEATHER

ROYAL PAISLEY

VANS X CURTIS KULIG

JUNGLE LX

NATIVE EMBROIDERY

WATERMELON

BIRDS EDITION

SURPLUS

STAR WARS

RIVET

OVERWASHED

BLACKSOLE

FLAMINGO

WHITE

DQM X VANS I LOVE NY

VANS X RAD

TIGER

HULA CAMO

HELLO KITTY

STAINED

SUPREME X PLAYBOY X VANS

HIKER PACK

VANS X KENZO - FLORAL PATTERNS

BEAUTY & YOUTH X VANS

SUPREME X VANS

VANS X OPENING CEREMONY
MAGRITTE COLLECTION

LX CAMP SNOOPY

RETRO FLAG

GOLD BAR

ZX 9000

This gray model, twin sister of the 8000, with bulkier looking yokes, was rereleased in leather in 2003.

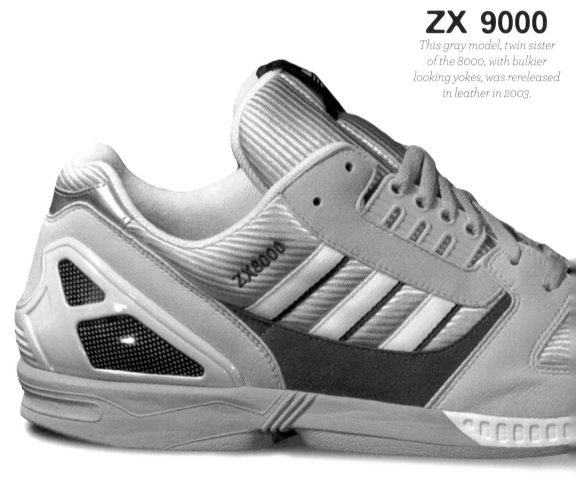

TORSION
An innovative articulated sole

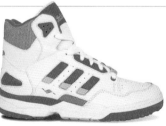

BANKSHOT
High-top

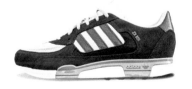

ZX 850 NAVY RED
USA Special

PASCAL BRUTAL

The ZX 8000 is the favorite sneaker of the eponymous hero of Riad Sattouf's French graphic novel series.

This running shoe made a big splash in the sports market by introducing Adidas's Torsion system.

The ZX 8000 was produced in 1988. It incorporated a new technology symbolized by a yellow bar set into the sole that served as an articulating joint between the front and rear of the foot, which were now separated. The idea was to give back to the runner a certain flexibility and stability, as well as a better transition of energy as the foot rolled through the stride. The Torsion system also reduced the sole's volume and, therefore, the shoe's overall weight (the enemy of every runner). And then there were the colors—electric blue with three yellow stripes—that reinvigorated sportswear shops dominated by drab, soulless, silver-gray models. The shoe was an immediate success with running aficionados, as well as in the schoolyard, not to mention in the London ragga scene—Lord knows why! The ZX 8000 was rereleased for its fifteenth and twenty-fifth birthdays, and also served as the basis for the ZX Flux (same heel, identical sole), which became very popular with high school students upon its 2014 launch.

DAVID BECKHAM

The English soccer player has a weakness for this sneaker.

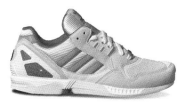

ZX 9000
The stockier twin

NEGATIVE ST NOMAD
Special 25th birthday

ZX FLUX
21st-century descendant

BUT WHERE'S THE SWOOSH?

1993

Launch of the Light model, on which the Swoosh reappeared.

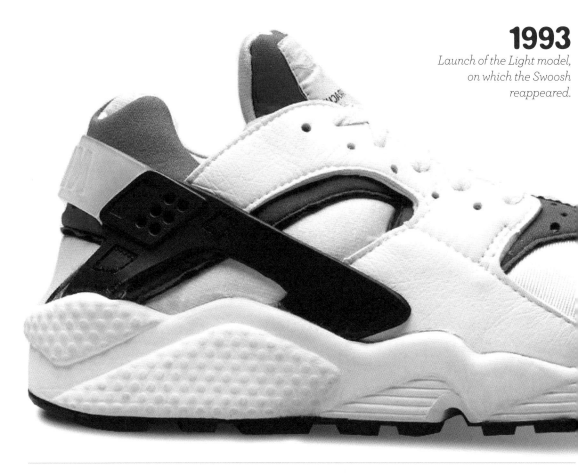

LIGHT
With the Swoosh

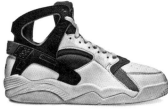

FLIGHT
The shoe of the Fab Five

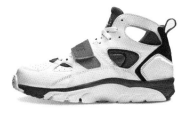

TRAINER
With the Velcro strap from the Air Trainer 1

FAB FIVE

*The nickname of the 1991
University of Michigan men's
basketball team—considered
by many to be the greatest ever—
who popularized the high-top
version in 1992.*

This logoless shoe, with a name as strange as its design, should never have seen the light of day.

One morning in 1990, Tinker Hatfield, Nike's star designer, unveiled his latest invention to the marketing department at the sneaker giant's headquarters in Beaverton, just outside Portland, Oregon. This was the Huarache, a running shoe comprised of a neoprene slipper inspired by waterskiing footwear. But it was neither the name nor the disruptive design—a clear break with the codes of the era—that so puzzled the marketeers. The crucial detail that got their attention was the disappearance of the famous "Swoosh." They all predicted that without the brand emblem, the shoe would be a commercial flop; indeed their skepticism was soon confirmed when total preorders were only a paltry 5,000 (twenty times less than the number required to justify full-scale production). The project was abandoned, but the small initial production was sold off to a distributor, who took the risk of selling the shoe during the New York City Marathon in 1991. The entire stock was snapped up in two days. The Huarache was saved, 250,000 units were ordered, and it became a best seller. In 2000, two collaborations with Stüssy created great excitement among sneaker fans, who would have to wait thirteen years for a rerelease of the original version, along with dozens of different prints and colors. It has been one of the "it" shoes of the last two years.

TARAHUMARA

*Huarache is the name of the sandal
worn by this Native American people
of northwestern Mexico, whose principal
means of covering long distances
is by running.*

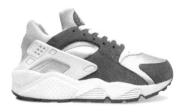

STÜSSY X NIKE AIR
Hipster

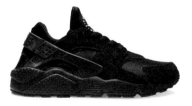

TRIPLE BLACK
Exactly what it says

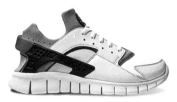

FREE
With an indented sole

TINKER HATFIELD

CREATOR OF PLANET SNEAKER

Almost as famous as the cult models he designed, Tinker Hatfield is quite simply the best sports shoe designer of all time.

Paris, June 12, 2015. A wing of the Palais de Tokyo devoted entirely to an exhibition covering the thirty years of Jordan Brand. Tinker Hatfield responds to journalists' questions, while Michael Jordan himself explores this retrospective in which he features hugely. A few minutes earlier, in front of the press, the champion spoke of the "genius" of the Swoosh brand's current vice president, who was in charge of design for special projects. The mastermind behind fifteen models of Air Jordan and a dozen other sneakers that are now cult items has frequently been questioned over the decades about the secret of his success, and he always gives the same answer: "When we design a shoe, we think of performance first and what an athlete requires in their shoes. There's also issues of style that we consider, but ultimately we want people to know they're buying a little bit of a dream." Hired as an architect by Nike in June 1981 to design office spaces for the firm's headquarters in Beaverton—a suburb of Portland—the former sprinter, pole-vaulter, and graduate of the University of Oregon started working on his first shoe designs four years later. He drew inspiration from both top-level sportspeople and Sunday joggers—to whom he always paid very close attention—as well as architecture, military aviation, car design, and his extensive traveling. Named as one of the one hundred most influential designers of the twentieth century by *Fortune magazine*, Hatfield now runs Nike's Innovation Kitchen, the design lab that might one day produce the next sneaker star.

Tinker Hatfield,
Nike's star designer, on the roof of the Palais de Tokyo, in Paris, in June 2015. "Haussmann's architecture in Paris is an eternal source of inspiration for me,"
he explained.

NIKE
ADIDAS
PUMA
NEW BALANCE
REEBOK
CONVERSE
ASICS – ONITSUKA TIGER
VANS
PONY
ALIFE
APL
BALENCIAGA
BATA
COMMON PROJECTS
DIADORA
ELLESSE
EMERICA
ETNIES

CHAPTER 2
REIGN OF THE BRANDS

ETONIC
FAGUO
FEIYUE
FRED PERRY
GOLA
GOURMET FOOTWEAR
PEAK
HUMMEL
LACOSTE
LANVIN
MONCLER
PIERRE HARDY
PRADA
RAF SIMONS
RICK OWENS
SAUCONY
SPLENDID
SPALDING
SUPERGA
SUPRA FOOTWEAR
TACCHINI
TERREM
UNDER ARMOUR
VALENTINO
VEJA
WILSON
WRUNG
YVES SAINT LAURENT
YOHJI YAMAMOTO
NIKE

U p until the mid-1970s, sneaker brands were exclusively associated with sports. Then came the birth of hip-hop culture in New York City, extending the influence of the brands beyond basketball and tennis courts and running tracks. In this ever-shifting underground galaxy—deejaying, graffitiing, break dancing)— the sports shoe became the ideal accessory to move, dance, and run, as well as a sign of community and style identity. The sneaker was pivotal to the sportswear tidal wave of the 1980s, and the brands fully capitalized on this over the following decade. They began a merciless war, fought with endorsement deals cut with the biggest athletes of the day, technological innovations, and attention-grabbing designs. Nike emerged as the big winner of the turbulent 1990s, having mastered the secrets of both cool design and pure performance, leaving other major brands trailing (Fila, Diadora, Ellesse, among others). These days, brands are less inventive, capitalizing on their timeless basics and their past best sellers, redesigned by a contemporary artist, another brand, or a trendy store, but most often by a major name in hip-hop, such as Jay-Z, Kanye West, and Pharrell Williams, to whom they clearly owe a lot. The sneaker business is currently estimated at more than $80 billion throughout the world, 20 percent of which is from the sports market and 80 percent from the lifestyle market.

NIKE, THE CREATIVE LEADER

Since 1972, the Swoosh brand has combined its quest for performance with unparalleled design. The world's number one sports outfitter is also the ultimate benchmark for sneaker addicts.

Five hundred dollars for an empire. In 1964, Phil Knight, a twenty-four-year-old middle-distance runner who had recently graduated from the University of Oregon, and his coach Bill Bowerman each invested five hundred dollars to launch Blue Ribbon Sports, a distributor for Japanese sports shoemaker Onitsuka Tiger. In 1971, this small local firm, which hitherto had focused on supplying the best athletes in the Northwest, took the name of the Greek goddess of victory, Nike. The company now has a turnover of $20 billion. What is the secret of its success? An innate flair for technological innovation, design, and marketing that is summed up in a single slogan—"Just do it," coined in 1988—and symbolized by the famous Swoosh. This logo represents its muse's wing, and was created by a graphic design student for just thirty-five dollars. The company also relied on sports champions to endorse its products, from its first ambassador, Steve Prefontaine, to Cristiano Ronaldo, by way of Michael Jordan and Andre Agassi. And Nike has seen almost all of its models adopted by street culture, from the 1980s until today.

The Air Rift, a hybrid model that is a cross between a sneaker and a sandal, was inspired by the natural, minimalist style of Kenyan runners.

37.7

BILLION DOLLARS

The estimated fortune of Nike cofounder, Phil Knight, in 2020.

LAVA DUNK

50 percent Dunk High, 50 percent ACG Lava Dome. For urban walkers.

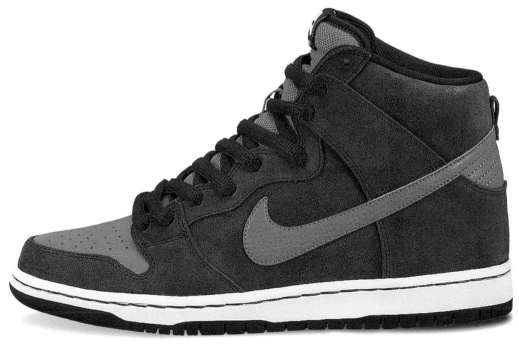

DUNK SB HIGH

The skateboarding version of the Dunk, in the colors of the Chicago Bears football team.

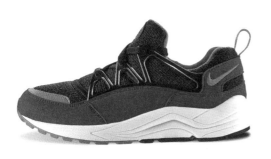

AIR HUARACHE LIGHT

AIR EPIC

AIR RALLY

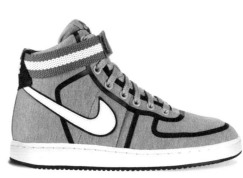

VANDAL HIGH SUPREME

VAPOR 9 TOUR

LAVA DOME

LAVA HIGH

AIR WILDWOOD

WMNS TERMINATOR

WINDRUNNER

AIR TRAINER HUARACHE

AIR FORCE CMFT MOWABB

AIR TECH CHALLENGE II

AIR PEGASUS

ROSHE FLYKNIT

DUNK LOW (VIOTECH)

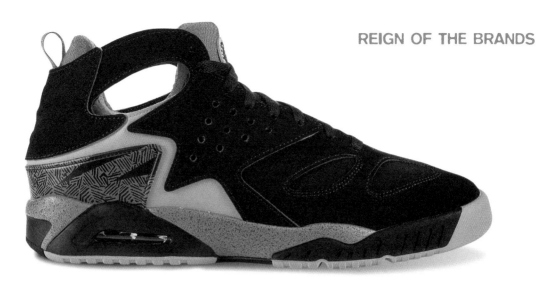

AIR TECH CHALLENGE HUARACHE
Andre Agassi's shoe, in the colors of the Phoenix Suns basketball team.

AIR MAG
A dozen pairs of the futuristic shoe from *Back to the Future 2* were produced in 2011 and sold at auction.

FLYKNIT

Designed for the London Olympics in 2012, the Flyknit was the first running shoe made from a single piece of knitted fabric.

AIR FORCE 1 MID X RICCARDO TISCI

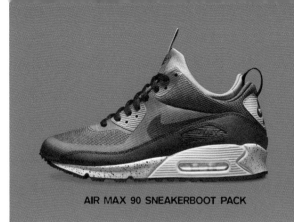

AIR MAX 90 SNEAKERBOOT PACK

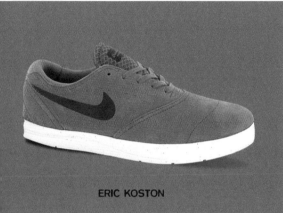

ERIC KOSTON

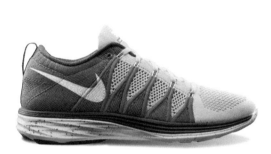

FLYKNIT LUNAR 2

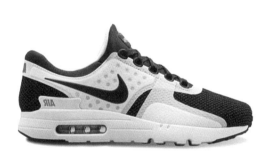

AIR MAX 0

AIR STAB

ROSHE SNEAKERBOOT PACK

BLAZER

THE BRAND WITH THREE LIVES

This German brand was born in 1949 as a result of a family squabble, and it dominated the sports market for many years before narrowly avoiding bankruptcy in the early 1990s. It is now experiencing a rebirth, second only to Nike in worldwide success.

A year after permanently falling out with his brother and business partner Rudolf—who launched Puma in 1948—Adolf Dassler renamed the family shoe firm—founded in 1924— by combining his nickname, Adi, and the first syllable of his surname. Mad about track and field, as well as soccer (he produced the first ever shoe with screw-on cleats, which helped Germany to win the World Cup in 1954), Adolf was obsessed with improving athletic performance. He died in 1978, living long enough to see the trefoil logo—created six years earlier—spread across playing fields the world over, as well as the rise of its greatest rival, Nike. But he would miss out on seeing Adidas's "fall" into the lifestyle sector in the 1980s, worn like an emblem by the hip-hop youth, and then as a casual accessory by men and women everywhere. In 1987, the sudden death of Horst Dassler, Adolf's son and successor, ushered in a tougher period. The company was losing momentum, and in 1990 it was bought out by the French businessman Bernard Tapie, who, two years later, sold it on to Crédit Lyonnais bank in a dubious financial deal that is still the subject of much legal controversy. Adidas had a brush with bankruptcy before being relaunched in 1994 by the businessman Robert Louis-Dreyfus. The company now turns over close to €15 billion a year, 30 percent of which comes from the Originals lifestyle range, launched in 2010, seven years after the debut of its fashion brand, Y-3, which was created in collaboration with the designer Yohji Yamamoto.

Run-DMC in 1985; they were the first artists to be sponsored by a brand.

TOP 10

ADIDAS IS ONE OF THE TEN BEST-KNOWN BRANDS IN THE WORLD, AND IS AVAILABLE ON FIVE CONTINENTS.

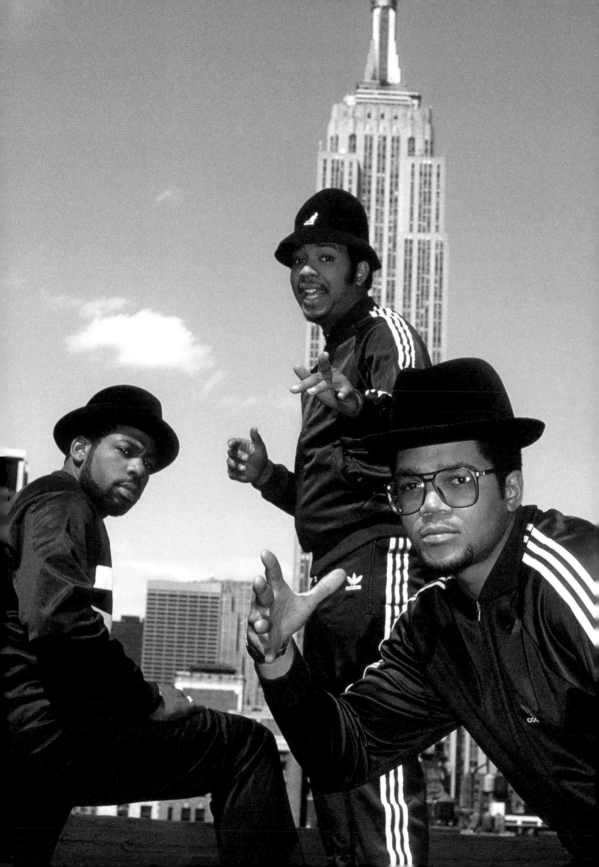

GAZELLE

In the early 1980s, the red version of the Gazelle was adopted by fans of Liverpool Football Club.
It is still worn today by "ultra" fans of British soccer teams.

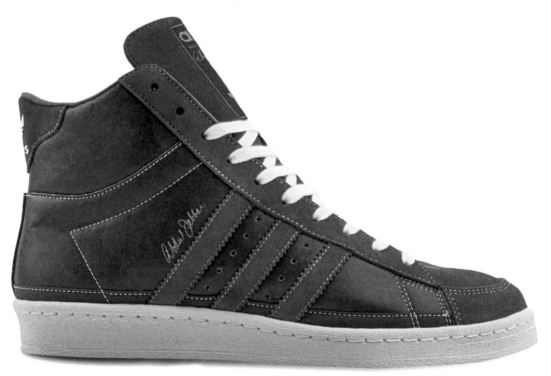

KAREEM ABDUL-JABBAR · THE BLUEPRINT

The NBA star of the 1970s and 1980s is often considered to be a model for the modern basketball player,
hence this shoe is called "blueprint" in homage to him.

JEREMY SCOTT - LETTERS

FLEETWOOD LOW

CRAZY

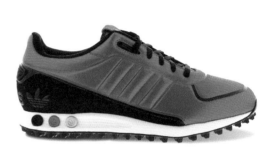

L.A. TRAINER

OREGON

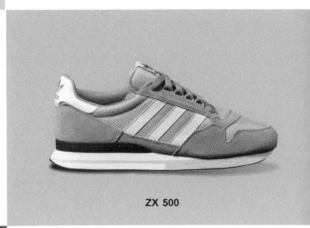

ZX 500

MICROPACER

NIZZA

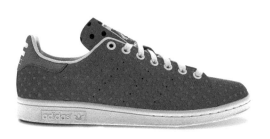

STAN SMITH X PHARRELL WILLIAMS

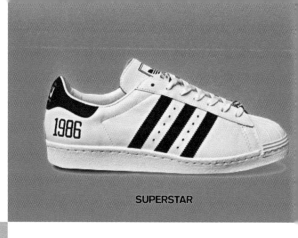

SUPERSTAR

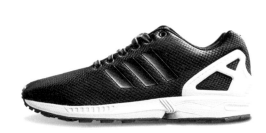

TOP TEN

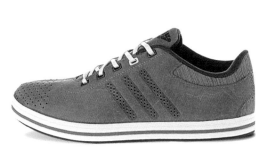

ZEITFREI

ZX FLUX

JEREMY SCOTT STREET BALL

KLEGER SUPER

ADIDAS X KZK NASTASE

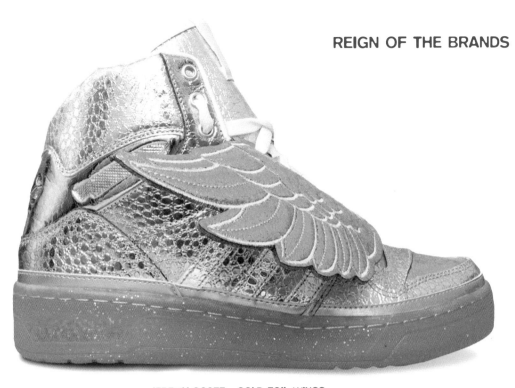

JEREMY SCOTT - GOLD FOIL WINGS
The American fashion designer and art director gave wings to the three-stripe brand.

DECADE
This symbol of 1980s basketball contains the DNA for the subsequent ten years of Adidas high-top models.

ADIDAS

ADIPOWER HOWARD 3
Designed for Dwight Howard, center for the Houston Rockets.

CONDUCTOR HIGH OLYMPIC
Used in the 1988 Seoul Olympics, the shoe of Patrick Ewing—star center of the New York Knicks
in the 1980s and 1990s—bears the Korean Sam-Taegeuk symbol, which is derived from Taoism
and represents heaven (blue), earth (red), and humanity (yellow).

OFFICIAL

APS

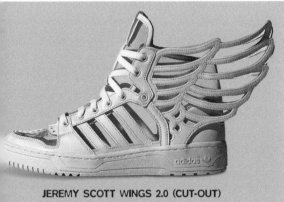

JEREMY SCOTT WINGS 2.0 (CUT-OUT)

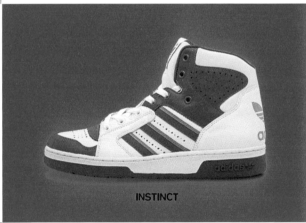

EQUIPMENT GUIDANCE

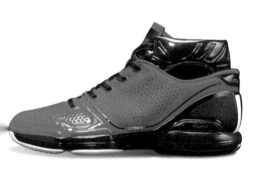

ADIZERO

INSTINCT

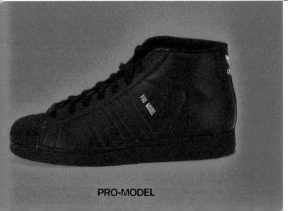

PRO-MODEL

ENERGY BOOST

PUMA, THE REBEL BRAND

The product of an intense sibling rivalry, Puma attracted the big names of sport and fashion to promote its style.

The town of Herzogenaurach, Germany, is home to both Adidas and Puma, two major sports uniform suppliers located just just two and half miles apart. Strange for a town of barely 23,000 inhabitants. This industry curiosity has its roots in a fierce quarrel between Rudolf and Adolf Dassler. Shoe manufacturers since 1924, the brothers had a falling out in spring of 1948. Rudolf, the elder, launched Puma in September. The brand then sought to attract the greatest champions, signing eye-watering contracts with soccer stars, such as Pelé, Eusébio, Johan Cruijff, and Diego Maradona—who made the Puma King the star of soccer schools everywhere—as well as with tennis players Guillermo Vilas and Boris Becker, and, later, the Formula 1 driver Michael Schumacher. Since 2007, Puma has belonged to the French group Kering. These days, the brand relies mainly on the Jamaican sprinter Usain Bolt, and has lost some ground to its competitors. Despite collaborations with many fashion designers, such as Alexander McQueen and Hussein Chalayan, Puma's best seller remains the Clyde.

Summer Olympics in Mexico City, 1968. Sprinters Tommie Smith and John Carlos protest against racial discrimination in the United States.

DISC

Amid the whirlwind of technological innovations of the early 1990s, such as Torsion, Air, and Pump, Puma launched the Disc system, in March 1992; the wearer turns a disc placed on the instep to tighten the shoe.

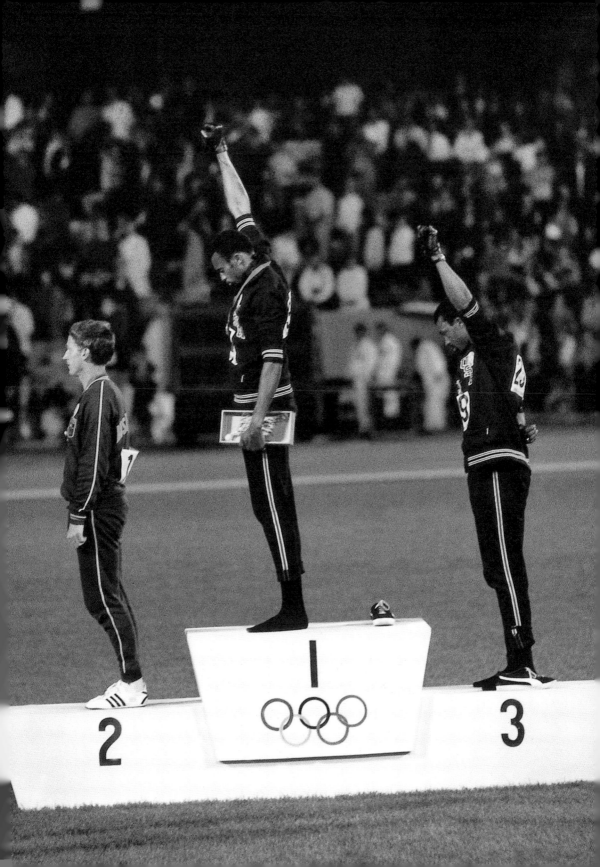

TOMMIE SMITH

"A POLITICAL MESSAGE"

October 16, 1968. On the podium of the 200-meter winners at the Mexico City Olympics, American athletes Tommie Smith and John Carlos showed their support for the civil rights movement by brandishing a black-gloved fist in the air —the Black Power salute—during the playing of the national anthem. But why on earth did they climb the podium in socks after carefully removing their Puma Suede sneakers, which they laid beside them on the podium? A publicity stunt? Tommie Smith explains.*

"The spectators didn't immediately understand what this gesture meant, since nobody had ever mounted an Olympic podium with sneakers, unless they were wearing them! It wasn't a publicity stunt for Puma. Just like the fist and the black glove, there was a political message. I wore socks without shoes to symbolize the poverty of black people in America, and to remind everyone that many of my compatriots couldn't afford to buy themselves this kind of shoe. Including me, by the way! Over the years, I beat dozens of records wearing other shoes and I never received a dime. I got no help, no letters, no encouragement. At the Mexico [City] Games, pole-vaulters, discus throwers, and shot putters were paid to wear these shoes [a practice forbidden at the time]. But Tommie Smith, the black athlete, never got anything. I even had to ask for track spikes in order to run. At the time, me and my wife could barely afford the rent for us and our ten-year-old son, Kevin. I was the holder of dozens of records, but I had to wash cars, collect bottles to take back to shops to claim the deposit and buy milk for my son. I was introduced to the Puma management by a friend a few months before the Games. I told them about my financial problems, and what we needed. They told me: 'OK, if you want to join the family, here's what we can do for you.' And they bought some Similac, a kind of milk with a special composition that my son needed. He became a world-class long jumper who even jumped with Mike Powell [world champion of the discipline in 1991 and 1993]. Since then, I have stayed loyal to Puma, not just because of the quality of their products, but also because they have good values and a friendly manner."

* Tommie Smith was interviewed by the author and Paul Miquel in June 2008 for French GQ magazine.

PUMA

MOSTRO

Nobody would have bet a cent on this strange shoe, with its double-crossed Velcro and its sole made for climbing.
Yet it is one of Puma's best sellers.

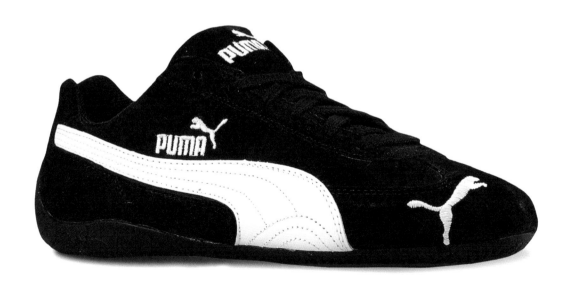

SPEED CAT

This Formula 1 driver's shoe with a tirelike sole was worn by one out of three students in the 2000s,
before disappearing as quickly as it arrived.

CHALLENGE ADVANTAGE

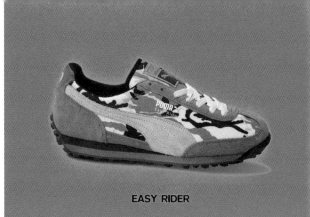

EASY RIDER

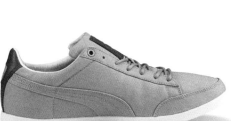

ARCHIVE LITE

CARO

CATSKILL CANVAS

COURT STAR

EL SOLO

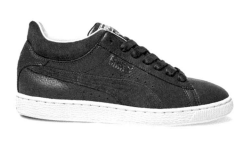

STEPPER CLASSIC

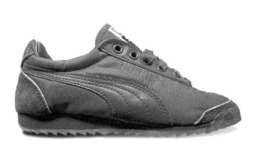

TAHARA

EVERFIT

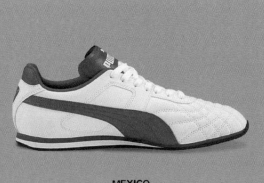

MEXICO

CLASSIC HIGH

'48

ICRA

MATCH

FIELDSPRINT

DALLAS
A minimalist version of the Suede, adopted by European B-boys.

RS1
In 1985, Puma attempted an innovation thirty years ahead of its time by inventing a running shoe equipped with a computer capable of recording all the useful data a runner might want. The RS-Computer never progressed beyond the prototype stage, but the RS1 did: same design, minus the technology.

PUMA

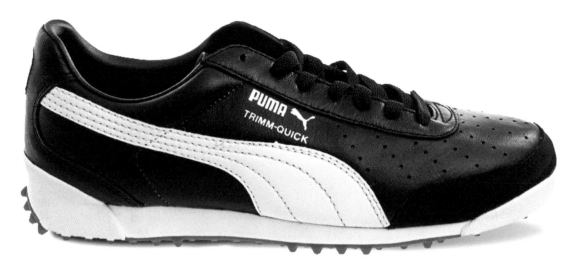

TRIMM-QUICK

A sports shoe equipped with the SPA technology (Sportabsatz, meaning "sports heel") that is supposed to protect the rear of the foot and reduce risks of injury by 30 percent.

SKY II

This sneaker manages to be both sturdy and lightweight, while its double Velcro straps ensure perfect support for the ankle. It was adopted by the players of the Los Angeles Lakers and the Boston Celtics.

SMASH

IBIZA

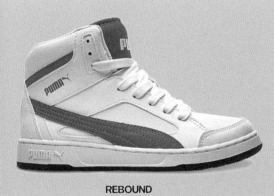

REBOUND

TARRYTOWN

ELSU BLUCHERTOE CANVAS

BEAST

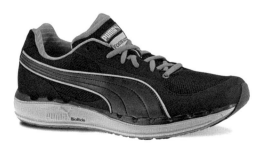

ST RUNNER

FAAS 500 M

NEW BALANCE, THE PERFECT EQUILIBRIUM

This American brand was formed in 1906 as a manufacturer of orthopedic soles. Since then it has become a classic, respected by runners and fashion addicts alike.

When you put on a pair of New Balance sneakers, you're struck by their unbelievable comfort. The brand was founded in the Boston suburb by English immigrant William Riley in 1906. New Balance started out producing orthopedic soles and shoes, incorporating a flexible arch support based on three support points, inspired by the foot of a chicken—whose three toes provide perfect equilibrium. In 1927, Riley hired Arthur Hall as a salesman, and Hall signed the first contracts with the police and fire departments of Massachusetts and Rhode Island. In 1925, New Balance produced its first running shoe, for the Boston Brown Bag Harriers, a local track club. But it was in 1961, with its Trackster model—fitted with small cleats and available in several widths—that the company really made an impact on the sports market, and became the successful running brand it is today. New Balance is also famous for the numbered names it gives its models—which are also very popular in the fashion world—as well as for having long resisted the mass outsourcing of production to Southeast Asia. Up until 2006, 70 percent of its shoes were made in the United States and at its Flimby plant in the United Kingdom, when other brands had long since made the choice of delocalization. In 2013, the brand hired its first ever ambassador, the Canadian tennis player Milos Raonic, having hitherto argued that its expertise and reputation sufficed to sell its shoes.

The 996 "American Flag." A patriotic brand, New Balance continues to make some of its shoes in the United States.

IN THE 1990s,

former president Bill Clinton unwittingly contributed to New Balance's success by wearing the 1500 for his highly publicized jogs.

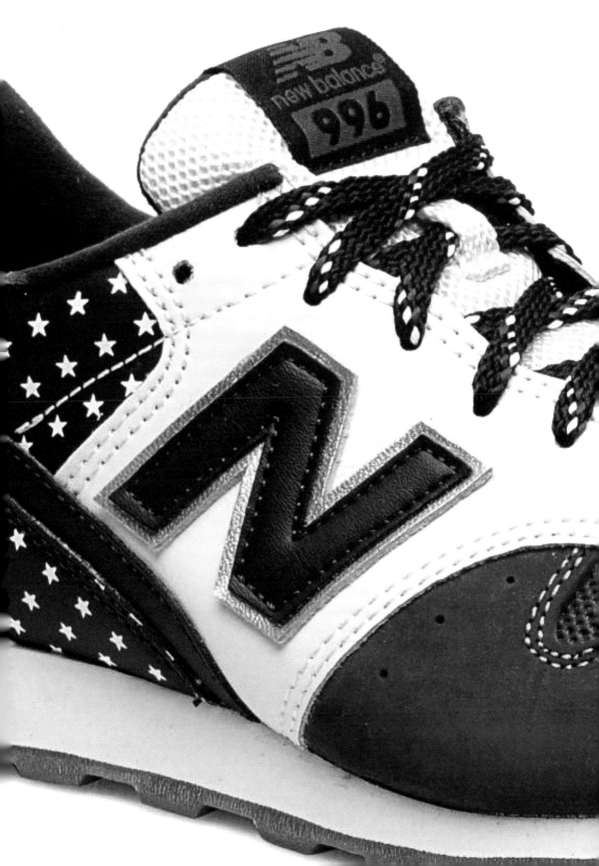

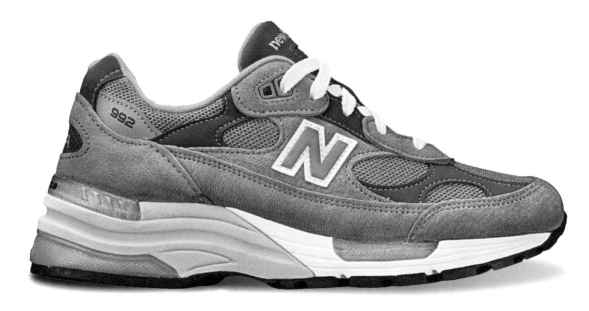

NB 992

Apple CEO Steve Jobs always wore the same outfit to present the company's latest innovations: faded jeans, a black Issey Miyake turtleneck, and a pair of New Balance 992s—now a cult shoe.

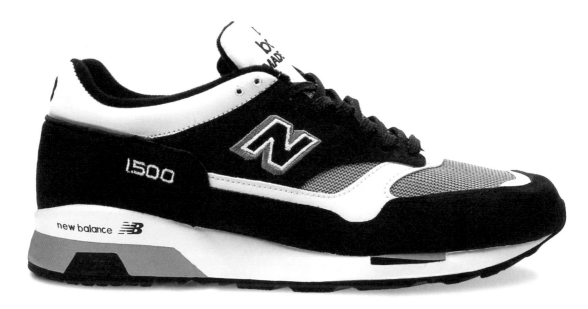

M1500

Finding itself in a trough during the 1990s, New Balance found itself an unlikely ambassador in the form of President Bill Clinton, who wore the 1500 on his daily jogs.

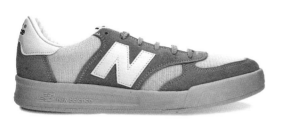

CT300

MC1296

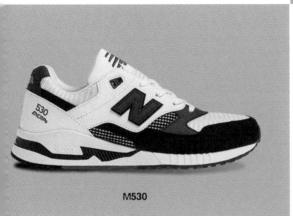

M530

MRT580 X MITA SNEAKERS

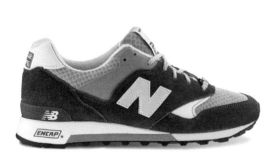

M577

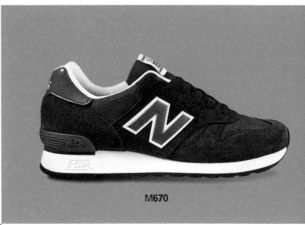

M670

K1300

M997

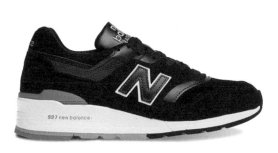

M997

CM1600

M574

M999

711 FITNESS

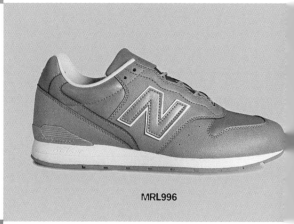

MRL996

M850

M576

NB 990 MADE IN USA

A unique model given to President Barack Obama in 2012 just before his presidential campaign, in order to remind him of the importance of American local industries.

NB 420

This weekend sneaker, worn by all and sundry, is nicknamed the Barbecue because of its association with leisure and good times, and also for its popularity.

NEW BALANCE

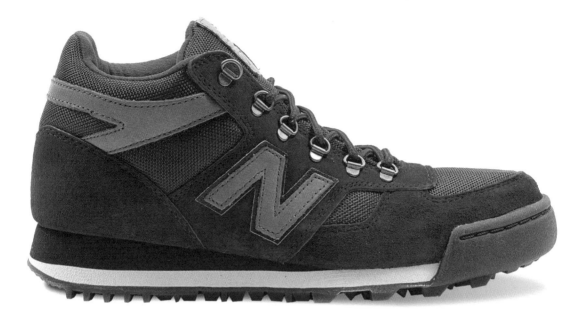

H710
The shoe's hiking boot appearance is a radical break with the traditional New Balance running shoe.

NB 980
Its ribbed sole incorporates Fresh Foam, the new-generation shock-absorption system appreciated by runners.

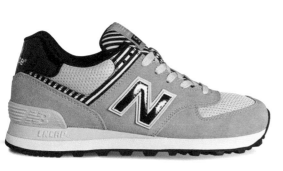

WL574

U410

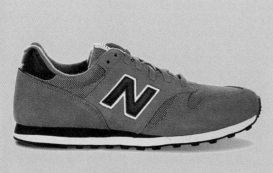

M373

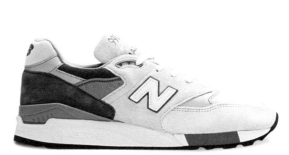

CONCEPTS X NB 998

CM620

M990 SLIP-ON

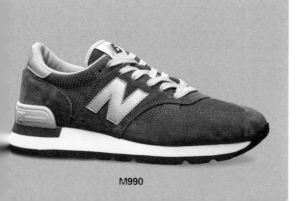

M990

M1400

REEBOK, THE GIANT WITH FEET OF CLAY

Having been independent at the peak of innovation for over a hundred years, this British institution has been slowly rising from the ashes under the care of Adidas.

Reebok is undoubtedly the brand of major firsts. Founded in Bolton, in North West England, in 1895—long before the likes of future rivals, such as Adidas, Puma, or Nike—Joseph William Foster's company made hand-sewn track shoes, which were worn by athletes at the 1924 Summer Olympics in Paris. In 1958, his grandsons renamed the company after rhebok, a species of African antelope. The firm was also the first to attack the American market with sixty dollar shoes (in 1979), the first to design a fitness model exclusively for women (the Freestyle, in 1982), and the first to disrupt consumer habits by introducing a manually operated compressed-air system (the Pump, in 1989).

Less positively, Reebok was also the first to give ground to its rivals in the 2000s—a time of crucial change—despite its luxury ambassadors: basketball players Shaquille O'Neal and Allen Iverson, and tennis player Venus Williams. Bought out by the Adidas empire in 2005, Reebok has spent the past five years redeveloping its fitness line, with a particular focus on CrossFit, a discipline very much in vogue, which combines elements of gymnastics, weight lifting, running, and other exercises.

The Pump, the schoolyard must-have of the 1990s.

3.5
BILLION DOLLARS

The value of Adidas's friendly takeover of Reebok—whose annual sales had exceeded $1.5 billion just twenty years earlier— on August 3, 2005.

BETWIXT
A fitness shoe for women, redesigned here by artist Olka Osadzińska.

WORKOUT MID STRAP GREEN NEON X KEITH HARING
The inimitable mark of the American artist, painter, and sculptor on the Reebok collection for Spring/Summer 2014.

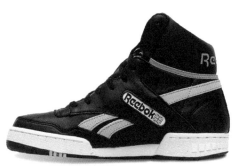

BB4600 HIGH

COMMITMENT MID

ERS 2000

PRO LEGACY

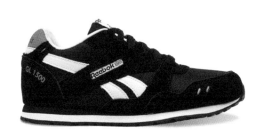

GL 1500

GRAPHLITE

KAMIKAZE

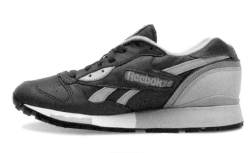

LX8500

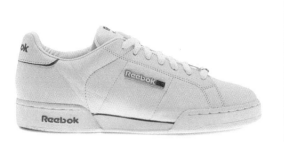

CLASSIC NEO LOGO

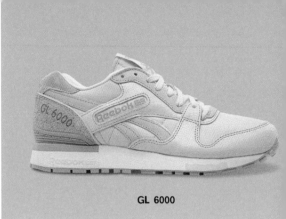

GL 6000

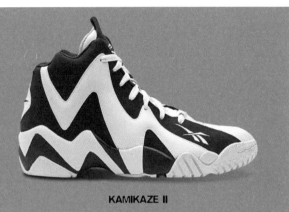

KAMIKAZE II

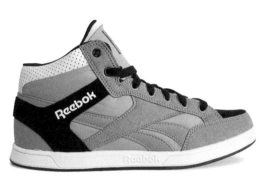

ROYAL MID

PRINCESS

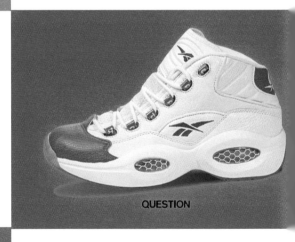

QUESTION

NPC FVS MID

INFERNO

DMX 10

In 1997, Reebok invented a new shock-absorption system, the DMX, to counter the hegemony of Nike's Air.

REALFLEX FUSION TR

The star of sports halls has a sole composed of fifty-three small, independent cleats to adapt to the movement of the foot.

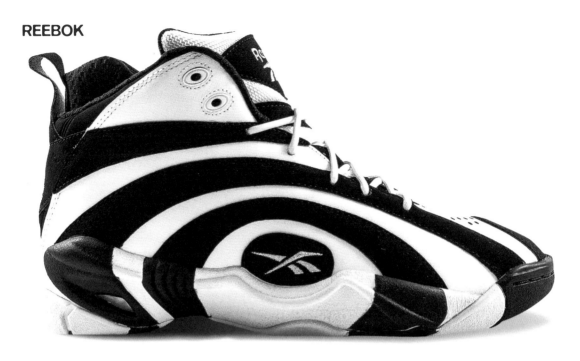

SHAQNOSIS

In the 1990s, Reebok produced a range of sneakers called Shaq Attaq, in reference to the aggressive style of basketball player Shaquille O'Neal. The Shaqnosis is one of the most famous in this range.

THE BLAST

Made famous by the fantastic basketball player Nick Van Exel in the mid-1990s.

Q96

SHAQ ATTAQ PHOENIX

KAMIKAZE III

SOLE TRAINER

VENTILATOR

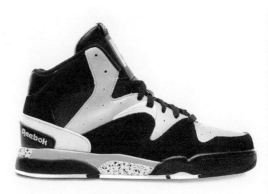

CLASSIC JAM

REEBOK ANSWER 1

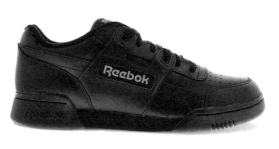

WORKOUT PLUS

CONVERSE, BORN UNDER A LUCKY STAR

A big hitter in the sports industry until the late 1980s, Converse is now a pillar of casual fashion with its cult sneaker: the All Star.

One day in Malden, Massachusetts, in 1908, Marquis Mills slipped on the stairs and decided to make a pair of shoes with gripping soles. Well, at least that's the story according to the legend... What's for sure is that Mills used his mother's maiden name, Converse, for his new enterprise. It was also the surname of his fourth cousin, Elisha, the town's very popular mayor and an industrialist who had made his fortune producing rubber shoes. Clever. The Converse Rubber Shoe Company very quickly made 4,000 pairs of fur-lined boots, but the smart businessman had bigger plans. In 1917, he began to produce a sports shoe, the Converse All Star, which, six years later, took the name of his best salesman, Chuck Taylor. The shoe would go on to sell over 800 million pairs. In the early 1970s, Converse, who also made boots for American military parachutists, bought from B.F. Goodrich Company the manufacturing rights for the Jack Purcell model—named after a Canadian badminton player. Then the company advanced its reputation by sponsoring the Los Angeles Olympics in 1984, and by associating its name to that of major basketball players, such as Julius Erving, Larry Bird, and Magic Johnson, and tennis players, such as Jimmy Connors and Chris Evert. However, the brand couldn't keep up with the competition in the 1990s, and Converse was obliged to deal with its $226 million debt by accepting a buyout offer from Nike, who has owned the brand since 2003.

Advertisement for Chuck Taylor by artist Roy Lichtenstein.

100,000
DOLLARS

Annual sum of the partnership deals made by Converse with NBA stars Larry Bird and Magic Johnson. Another era.

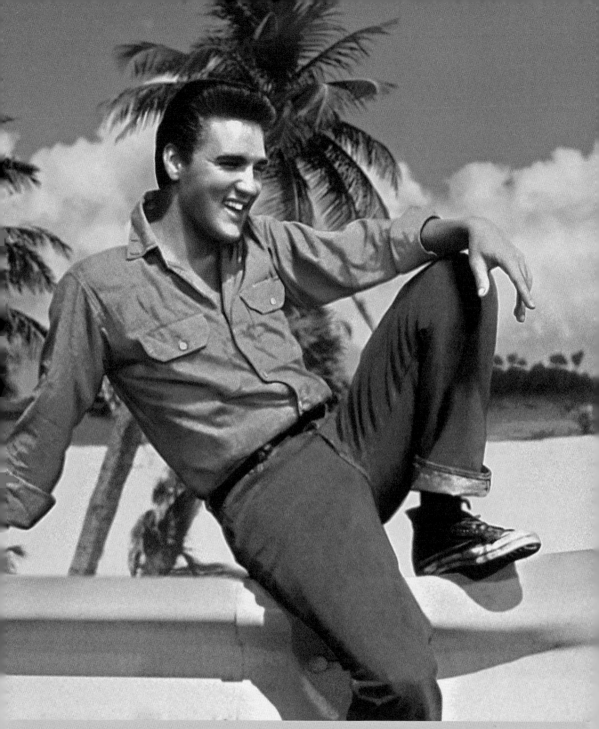

ELVIS PRESLEY, 1962

The future King is seen here on the set of Follow That Dream *in 1962. The All Star had already been adopted by working-class America, but it now became the shoe of choice for cool kids.*

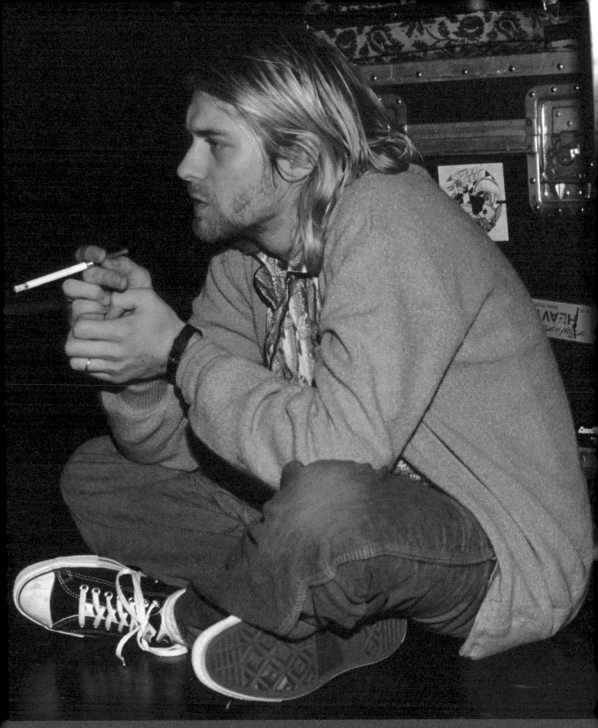

KURT COBAIN, 1990

Kurt Cobain, the lead singer of Nirvana, didn't change his look much: a slightly too-long cardigan, a washed-out shirt or shapeless T-shirt, ripped jeans, and always a pair of Converse on his feet, usually black All Star but sometimes Jack Purcell.

KA-ONE
The skateboarders' favorite Converse, redesigned by modern skating legend Kenny Anderson.

MALDEN ARCTIC
Converse reconnects with its origins and its first models, which were designed to keep feet warm in winter.

AERO JAM 2

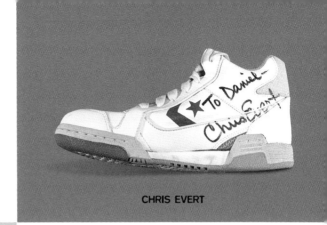

CHRIS EVERT

BREAKPOINT

CTS OX CAMO

PRO STAR

PRO BLAZE

MATCHPOINT

ONE STAR BY JOHN VARVATOS

PRO FIELD HI

TRAPASSO PRO

MALDEN RACER

ROADSTAR

CHUCK TAYLOR BOOT

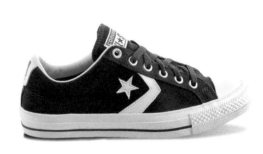

STAR PLAYER

SEA STAR

TIME LINE ONE STAR

WEAPON MAGIC JOHNSON
A sneaker in the colors of the Los Angeles Lakers, with the added class of Magic Johnson,
who would make it his favorite weapon.

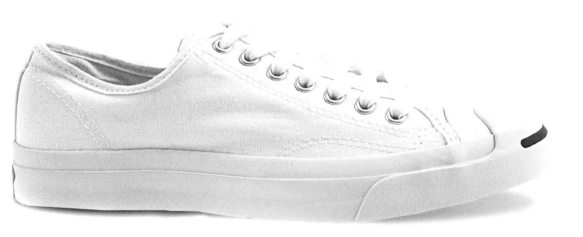

JACK PURCELL
Recognizable by its smile-shaped toe, this elegant tennis shoe was designed
by the eponymous Canadian badminton player in 1935.

CONVERSE

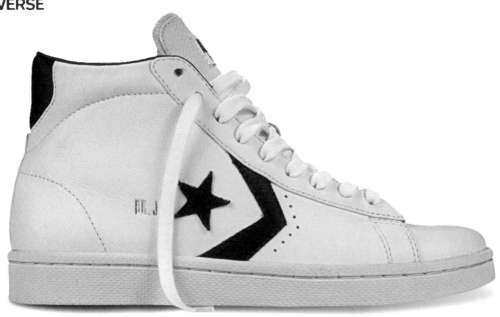

PRO LEATHER DR J
The amazing Julius Erving—alias Dr. J—won his only NBA title with this star sneaker, in the early 1980s.
The shoe would provide inspiration for the Adidas Pro Model.

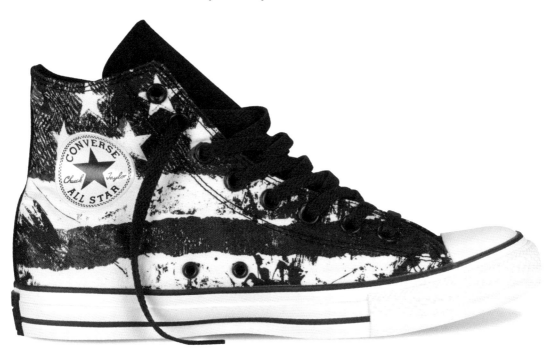

CHUCK TAYLOR ALL STAR
One of the hundreds of arty versions of the first ever sneaker.

CVO

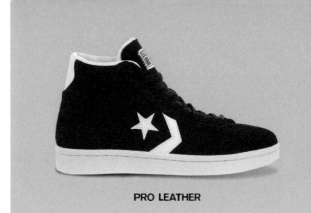

PRO LEATHER

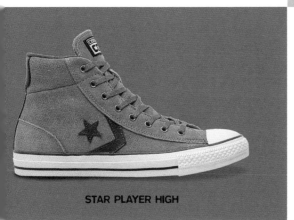

STAR PLAYER HIGH

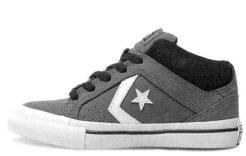

GATES

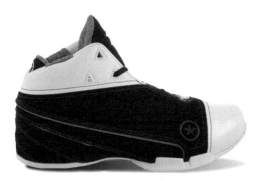

DWAYNE WADE

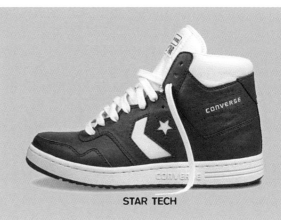

STAR TECH

ICON PRO

ODESSA

ASICS · ONITSUKA TIGER, THE SAFE BET

The Japanese brand has been a historic leader in the running market, and enjoys a great reputation on planet sneaker thanks to the Mexico 66 and the Gel Lyte III.

Kihachiro Onitsuka, a Japanese shoemaker, made his first pair of sports shoes in 1949, when he was thirty-one years old, initially for basketball, then soon after for running—which is what has made the brand world-famous, even today. In 1951, his first running shoe—designed in a soft material to avoid causing blisters —crossed the finish line of the prestigious Boston Marathon in first place, on the feet of Shigeki Tanaka. The brand went international the following decade, initially at the Tokyo Olympics in 1964, when Abebe Bikila, who had won the marathon at the 1960 Rome Olympics barefoot, retained his title after being persuaded to run in a pair of Tigers, then in 1966 with the Mexico, the first model with "scratch marks" across the sides, which Bruce Lee would make famous in *Game of Death*, in 1972. That year, Phil Knight, a distributor of the brand in the United States, took inspiration from his Japanese supplier to establish the future Nike empire. In 1977, Onitsuka merged with the sportswear company GTO and Jelenk to form ASICS. Amid the innovative frenzy of the mid-1980s, ASICS invented Betagel, a shock-absorbing material made of gel and silicone, which was injected into the sole of the Gel Lyte II—a best-selling running shoe. Like many of its competitors, ASICS has spent the past twenty years exploring other sectors, such as tennis and rugby, without committing the error of neglecting its core business, the running sector, of which it is today number one in the world.

Bruce Lee on the set of Game of Death (1972), wearing a pair of Mexico 66s.

ASICS

is an acronym for the Latin phrase anima sana in corpore sano (a healthy soul in a healthy body).

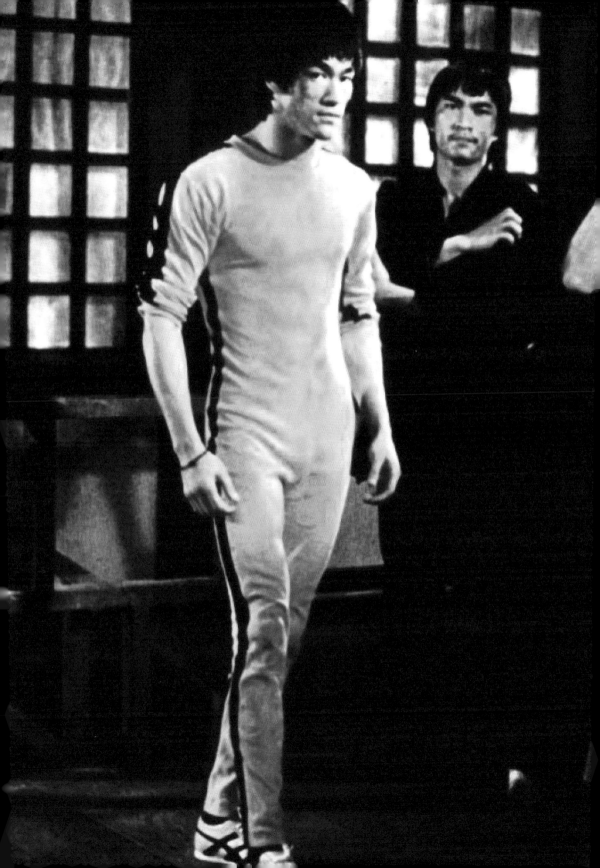

GEL LYTE III

The most advanced running shoe developed by the Japanese brand is a hipster icon today.

ULTIMATE 81

The Mexico's cousin, with the addition of a waffle sole, was rereleased in 2002 as the Ultimate 81 SD, to great success.

BURFORD

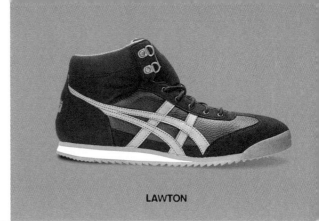

LAWTON

FARSIDE

MEXICO 66

GEL SUPER J33

GT 1000

SUNOTORE LE

GEL SAGA

LAWNSHIP

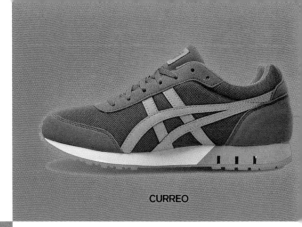

CURREO

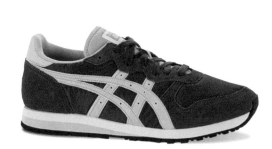

T-STORMER

GEL LYTE 33™

OC RUNNER

COLORADO EIGHTY-FIVE

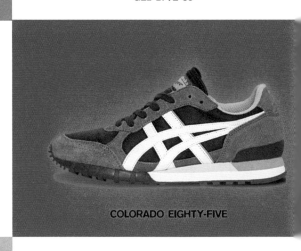

GEL PURSUE™ 3

GEL KINSEI® 5

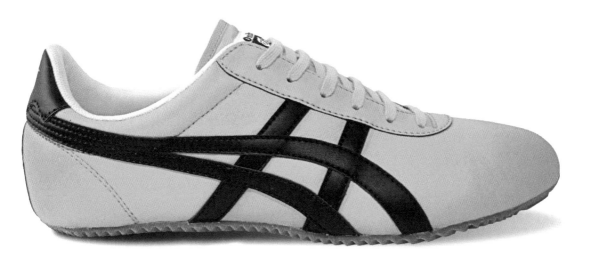

TAI-CHI
A special martial arts shoe immortalized by Uma Thurman in *Kill Bill*, in 2003.

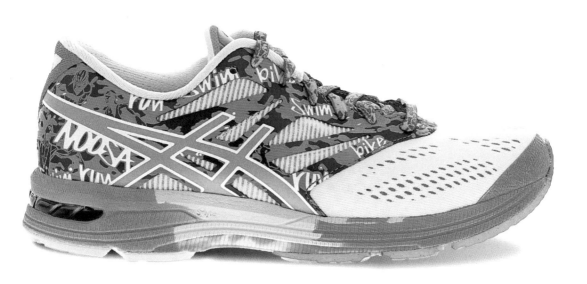

GEL NOOSA™
A flash of color on the feet of triathletes.

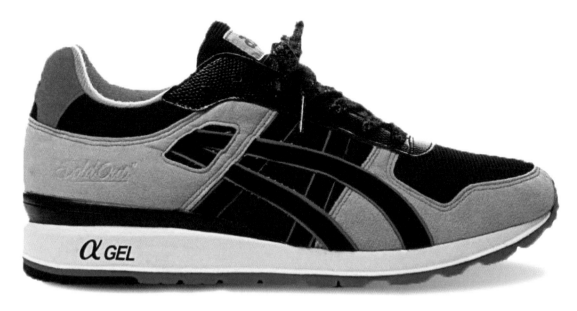

GEL LYTE II SOLD OUT
Just one hundred pairs were made of this model, designed by the Paris boutique Colette and the agency La MJC.

FABRE
The name is the blend of "fast break," a tactical maneuver in basketball, where a team suddenly switches from a defensive system to an offensive strategy.

SAKURADA

SHAW RUNNER

SHERBONE RUNNER

AARON

TIGER CORSAIR

FUJIRACER

GOLDEN SPARK

NIMBUS® 16

VANS, THE ICON OF SKATEBOARDERS

Vans has dominated skateboarding since the mid-1970s with its flexible, sturdy, and colorful shoes. Yet things nearly turned sour.

In 1965, thirty-five year-old Paul Van Doren was vice president of Randy's —a shoe manufacturer on the East Coast—when he decided to drop everything and take his wife, five kids, and his brother, James Van Doren, to California. A few months later, the two brothers, both big sports fans, opened the first Vans store, in Anaheim. They distributed their own skateboarding shoes themselves to keep the price down, and in 1976 Vans launched the model that would make the brand's name: the blue and red Era, worn by skate stars such as Tony Alva and Stacy Peralta. Sales exploded, and the brand launched a succession of cult models, such as Slip-On and SK8. They got free advertising in 1982, when Sean Penn wore a black-and-white checkerboard pair in *Fast Times at Ridgemont High*. His role of a joint-smoking surfer fit marvelously with Vans' rebellious image, and made the shoe a part of mainstream pop culture. Yet it was also the beginning of the end. Vans aimed too high and tried to break into other sports, but the gamble failed. Costs soared, inspiration was sluggish, and the company went bankrupt. A series of buyouts followed between 1988 and 2004, before Vans returned to its roots, and managed to win back skateboarders' hearts.

Steve Caballero, star skateboarder of the 1980s, helped take Vans to the top.

#44

The name of the brand's first model, released in 1966.

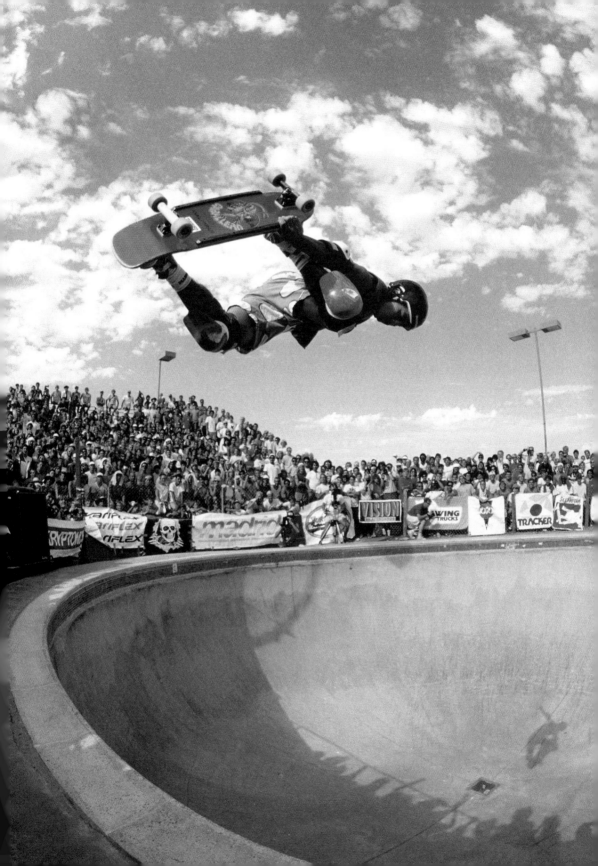

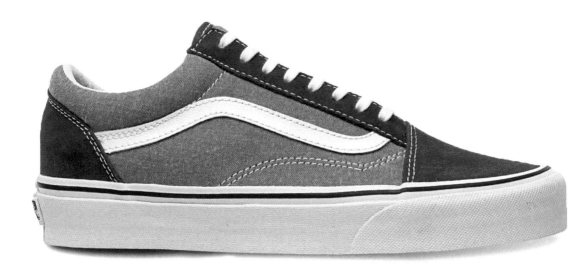

OLD SKOOL (ABOVE)/ SK8-HI (BELOW)

These two models saw the birth of the "jazz stripe," which was introduced in the 1980s to underscore the brand identity. The SK8 protected the ankles of several generations of skaters, enabling them to perform the craziest tricks.

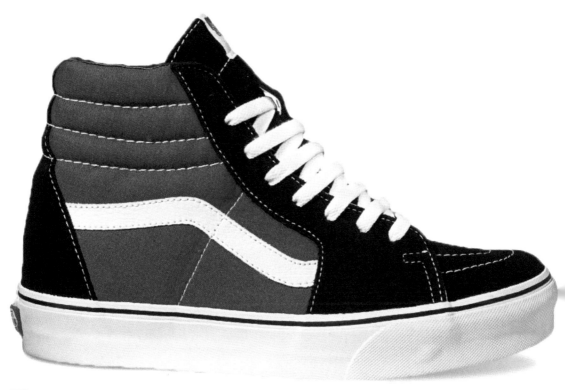

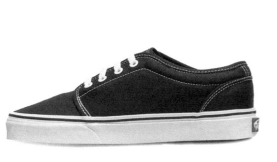

106 VULCANIZED

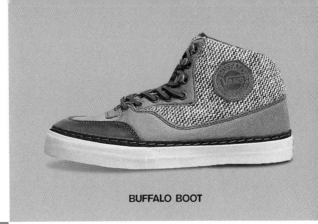

BUFFALO BOOT

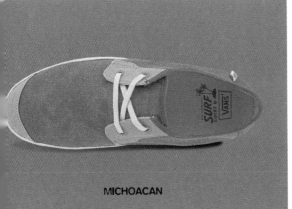

MICHOACAN

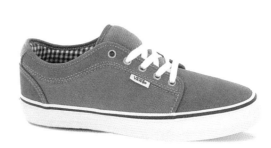

CHUKKA LOW

COSTA MESA

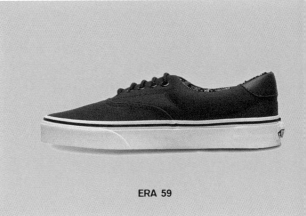

ERA 59

TRIG

LINDERO SUEDE

CHAUFFEUR

LPE

LUDLOW

MADERO

OTW BEDFORD

PROP

ROWLEY PRO

STYLE 36

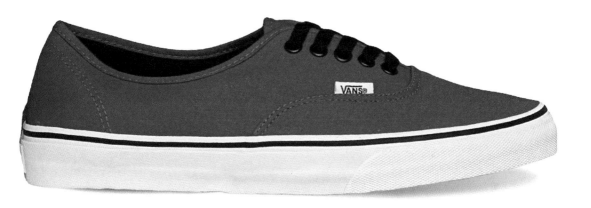

AUTHENTIC (ABOVE)/ ERA (BELOW)

The Authentic, previously known as the #44, was the brand's first model, prefiguring the entire Vans dynasty.
The Era, a sturdier and more comfortable version, was produced for skate stars Tony Alva and Stacy Peralta.
The subtle difference is the thickness of the ankle cuff.

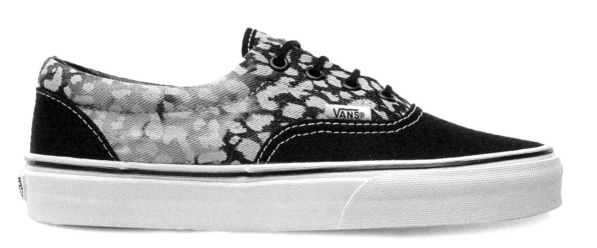

HALF CAB

With its combination of flexibility and sturdiness, the Half Cab gave Vans fresh impetus in the 1980s, when the brand was somewhat coasting.

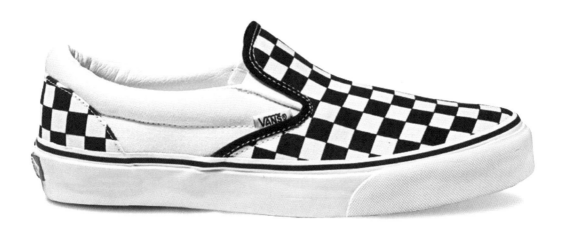

SLIP-ON

BMX purists still wear this laceless shoe.

BRETON

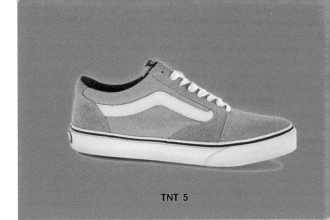

TNT 5

RATA VULCANIZED

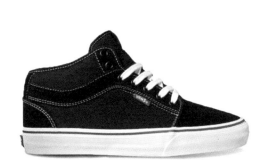

CHUKKA MID

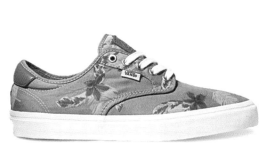

CHIMA FERGUSON

SLIP-ON AGED LEATHER

OLD SKOOL X WOLF GANG

ZAPATO DEL BARCO

PONY, THE FORGOTTEN BEAUTY

Pony was the star of US basketball and tennis courts in the 1970s and 1980s, but was unable to resist its giant rivals in the decades that followed.

Launched by Roberto Müller in New York in 1972 (supported financially by Horst Dassler, CEO of Adidas), Pony (acronym for Product of New York) initially provided shoes to the players of the ABA (American Basketball Association, a now-defunct basketball league since its merger with the NBA in 1976), as well as the two greatest champions of the time: the soccer player Pelé and the boxer Muhammad Ali. Pony's renown grew in the early 1980s, thanks, firstly, to the Tracy Austin tennis shoe, named after the youngest player ever to win the US Open, in 1979, and, secondly, to its Linebacker model (1983), recognizable by its tongue folded over the instep. Designed for the colossi of football, the Linebacker was produced in the colors of all the franchises in the National Football League, and was very quickly adopted by the fans—particularly children, who turned the street version into a true rallying symbol. But the brand lost its way in the 1990s—the golden age of sneaker culture. A kid would be ridiculed for wearing Top Stars or Midtowns in the schoolyard, whereas they'd have been the champion of cool just ten years earlier. Bought by a California firm in 2001, the brand attempted a comeback by producing collections for musicians, such as Limp Bizkit, Snoop Dogg, and Justin Timberlake, but has not been able to regain its previous luster. Cutting-edge hipsters are now trying to revive its coolness.

Spud Webb, who stands at 5 feet 7 inches tall, was the surprise winner of the Slam Dunk Contest in 1986.

16

Tracy Austin's age when she became the youngest tennis player to win the US Open in 1979, wearing a pair of Ponys bearing her name.

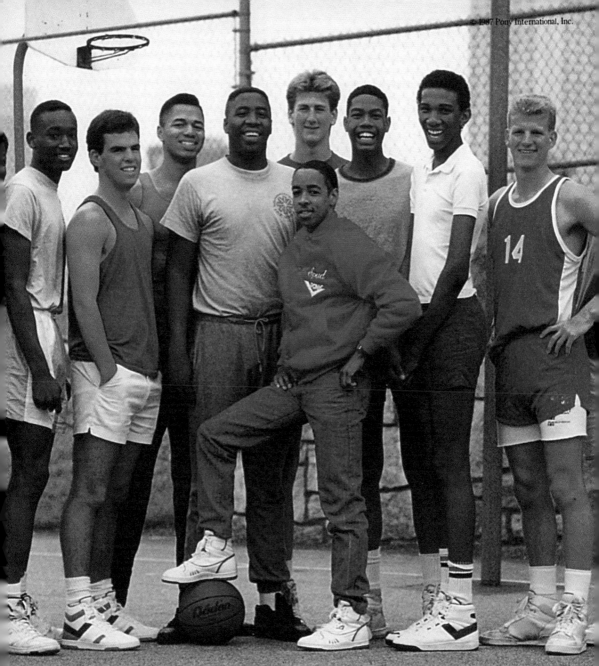

© 1987 Pony International, Inc.

Spud Webb

**THE OFFICIAL SHOE
OF THE 5'7" GUY EVERYONE LOOKS UP TO.**

MIDTOWN
Any resemblance with the Nike Air Force 1, launched three years earlier, is purely coincidental.

M110 X RONNIE FIEG
In 2014, New York sneaker designer Ronnie Fieg breathed fresh life into the M110, a robust, and now forgotten, model from the Pony back catalogue.

M100

RUNNER NYLON

BLENDER

SLAMDUNK VINTAGE

TRACKITBACK

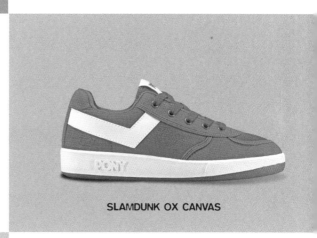

SLAMDUNK OX CANVAS

SMILEY X PONY M100

RICKY POWELL X PONY

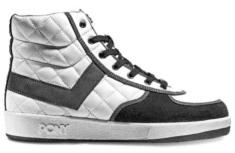

LEADERS 1354 X PONY

PRO 80

SMILEY

M110

MVP

TOP STAR LOW

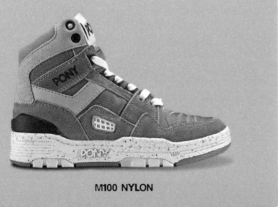

M100 NYLON

TOP STAR CANVAS NYLON

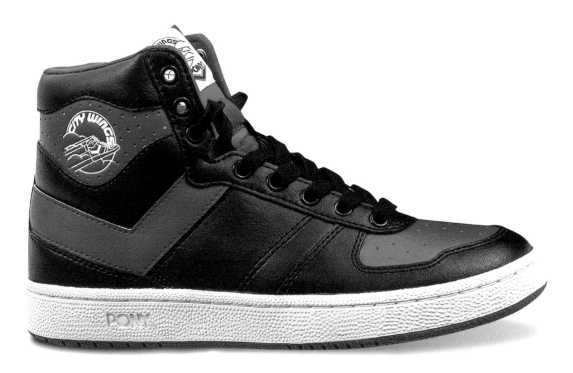

CITY WINGS

Any resemblance with the first Nike Jordan, released one year earlier, is purely coincidental. Really.

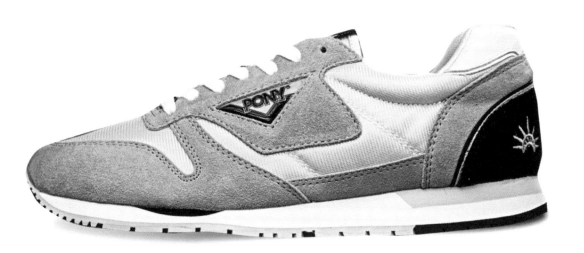

RUNNER LADY LIBERTY

This rerelease of the Runner in 2015, a collaboration between Pony and the Berlin boutique Overkill, is a reminder that the New York brand is not merely a basketball specialist.

PONY

COLETTE X PONY

This women's Top Star evokes the one worn by the tennis player Tracy Austin,
the youngest ever winner of the US Open.

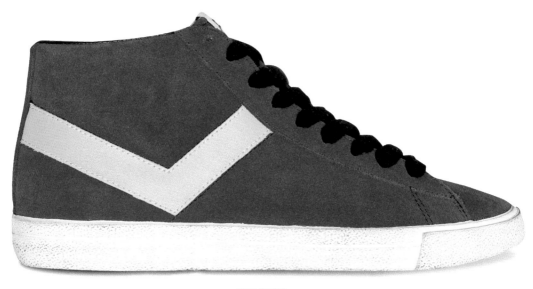

TOP STAR

This star of basketball courts in the 1970s became a symbol of tackiness in the 1990s, but is now a fashion must-have.

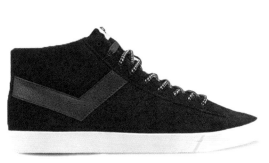

TOP STAR HI SUEDE

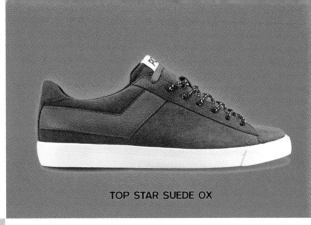

TOP STAR SUEDE OX

CITY WINGS NYLON

M110 OG

ROTHCO X PONY

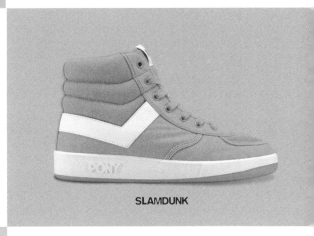

SLAMDUNK

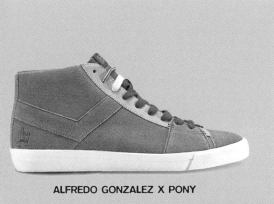

ALFREDO GONZALEZ X PONY

DEE & RICKY X PONY

GOING BEYOND

It would be wrong to limit the great story of sneakers to a handful of giant brands and a few of their challengers. Nike, Adidas, and company may well be currently setting the tone and the major trends, not to mention swallowing the major share of a booming global market (estimated at $58 billion in 2018 and forecast to reach $88 billion in 2024), but sneaker culture has also seen a number of other great brands, which have now fallen into oblivion, such as the lovely Italian trio of Fila, Ellesse, and Sergio Tacchini from the 1970s and 1980s. And there have also been occasional successes—for reasons that are often unclear—by much smaller and less powerful manufacturers, who are, nonetheless, becoming more numerous, and have their own loyal followings.

Nor would an anthology of sneakers be complete without the mention of the major role played by the large luxury and fashion houses who, since the early 2000s, have added high-end, and now famous, sneakers to their collections. A few examples are the SL10 by Yves Saint Laurent, otherwise known as the "luxury Jordan," the basics B01 by Dior Homme, and High by Lanvin, the latter two being casual-chic best sellers.

58
BILLION DOLLARS

The estimated value of the global sneaker market in 2018.

ALIFE - PUBLIC ESTATE MID

APL - CONCEPT 1

BALENCIAGA - ARENA

BATA - NORTH STAR

COMMON PROJECTS – ACHILLES

DIADORA - EQUIPE STONE WASH

ELLESSE - FAB 5

EMERICA - THE REYNOLDS

ETNIES - JAMESON 2

ETONIC - TRANS AM

FAGUO - OAK

FEIYUE - FE

FRED PERRY - KINGSTON

GOLA - QUICKSAND

GOURMET FOOTWEAR - THE 35 LITE

PEAK - PROSPECT

HUMMEL · STADIL
The Danish brand's star sneaker is also the favorite of Daniel Craig, alias James Bond.

LACOSTE · MISSOURI
The big names in fashion regularly take inspiration from sports brands, as Lacoste does here with the Nike Air Trainer 1.

LANVIN · HIGH
One of rapper Kanye West's favorite luxury sneakers.

MONCLER · MONACO
The Italian brand doesn't only make excessively priced down jackets, but also classic, simple, and elegant sneakers.

PIERRE HARDY · POWORAMA

PRADA · LINEA ROSSA

RAF SIMONS · HI-TOP STRAP SNEAKERS

RICK OWENS · RAMONES SNEAKERS

SAUCONY · GRID 9000

SPLENDID · SOLVANG

SPALDING · PIXIES

SUPERGA · 2750

SUPRA FOOTWEAR · OWEN TRAINER

TACCHINI · PARIGI

TERREM · PUBLIC

UNDER ARMOUR · CURRY ONE

VALENTINO · RED CAMOUFLAGE ROCK RUNNER SNEAKERS

VEJA · TAUA

WILSON · PRO STAFF

WRUNG · DESTRO

YVES SAINT LAURENT · SL10
There's a quite a bit of Air Jordan 1 in this Yves Saint Laurent shoe.

YOHJI YAMAMOTO · Y-3 QASA
With his immediately recognizable style, Japanese designer Yohji Yamamoto has been collaborating with Adidas since 2003.

AIR YEEZY 2 RED OCTOBER
AIR JORDAN XII FLU GAME
AIR JORDAN XII OVO DRAKE
AIR FORCE 1 BOGEYMAN
AIR MAG
AIR JORDAN 2 (1986 OG)
KOBE AIR ZOOM 1
AIR JORDAN 1 BLACK GOLD (1985)
AIR JORDAN 11 BLACKOUT
ARTHUR ASHE
BJÖRN BORG
JIMMY CONNORS
STEFAN EDBERG
IVAN LENDL
ILIE NASTASE
YANNICK NOAH
ROD LAVER
GUILLERMO VILAS

CHAPTER 3
TOP OF THE BASKET

AIR FORCE 180 OLYMPIC
33 HI
KD 7
THE DREAM SUPREME
CITY WINGS
KB X
CONTROL HI
GRANT HILL
LEBRON 12
ALIEN STOMPER
STAN SMITH BLACK
AIR FLOW
SLIP-ON CHECKERBOARD
AIR JORDAN 4 GS
ZISSOU
COUNTRY
AIR COMMAND FORCE
SKY FORCE 88 MID
AIR WOVEN HTM
CHUCK TAYLOR ALL STAR
BRUIN LEATHER
AIR MAX TRIAX
VANDAL
ZX 850
STAN SMITH
100 MM
CHUCK TAYLOR ALL STAR
FIRST COURT
FREE

We'll never know which sneaker is the greatest, the most fascinating, or the most beautiful of all time. It is vain, even illusory, to want to answer the question. A G7 of sneaker experts wouldn't succeed in doing so. Why? Because nobody could agree on just one shoe. And so much the better. Each country, generation, lifestyle, decade, trend, sport, or culture has its own legendary totem, an unshakable monolith, an ultimate reference, a fitting style. To put it less grandiloquently, it is also, above all, a question of taste. And that is indisputable. So how can we get past omniscience? How can we choose among the thousands of sneakers invented, designed, and redesigned over the last hundred years, and put together a wardrobe that is historic, varied, and ideal? How, without offending anyone, can we decree that such and such a model has (or doesn't have) its place in a top-ten or best of list, as this chapter proposes to do? By consulting reference books, specialized sites, and erudite blogs; by scrutinizing the choices of stars and other trendsetters who, whether we like it or not, set the tone and forge trends in the sneaker world; and, let's admit it, by giving in to one's more personal tastes. Without pretension. And without having the impudence to want to separate the real from the beautiful. Who could do that?

TOP MOST EXPENSIVE

Rare, made of expensive fabrics, or simply souvenirs of a sporting exploit, these sneakers sometimes sell for over $100,000. And, yes, they do have buyers. Take the Air Yeezy 2 Red October, of which just a few pairs were produced. They went on sale on February 16, 2014 and sold out in eleven minutes. One buyer immediately put them on eBay, attracting bids of up to $16,394,000.

NIKE AIR YEEZY 2 RED OCTOBER
$16,394,000

NIKE AIR JORDAN XII FLU GAME
$104,000

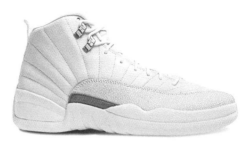

NIKE AIR JORDAN XII OVO DRAKE
$100,000

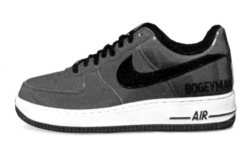

NIKE AIR FORCE 1 BOGEYMAN
$99,000

NIKE AIR MAG
$37,500

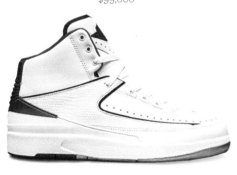

NIKE AIR JORDAN 2 (1986 OG)
$31,000

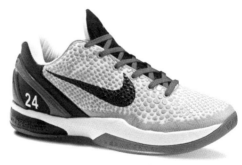

NIKE AIR ZOOM KOBE 1
$30,000

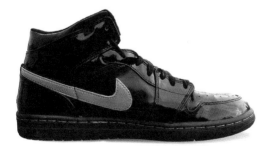

NIKE AIR JORDAN 1 BLACK GOLD (1985)
$25,000

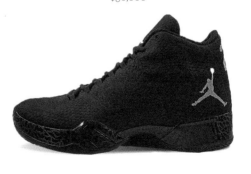

AIR JORDAN 11 BLACKOUT
$11,267

TOP TENNIS PLAYERS
(EXCEPT STAN SMITH)

The name of Stan Smith, the mustachioed American dandy, remains the most famous and best-selling tennis shoe in the world, but other tennis players have also been associated with footwear. There was the Diadora of Swede Björn Borg, winner of eleven Grand Slam tournaments (six French Opens, five Wimbledons) between 1974 and 1981. Or that of the mercurial Ilie Nastase—world number one in 1973—whose white Adidas with blue stripes were worn by many teenagers in the 1980s as they zipped around on their mopeds, the tailpipes dirtying the white canvas uppers.

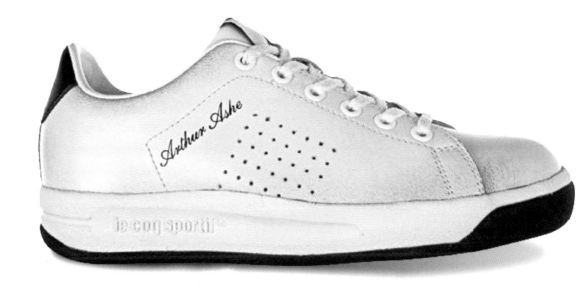

ARTHUR ASHE
Le coq sportif

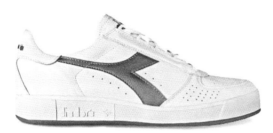

BJÖRN BORG
Diadora

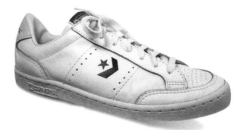

JIMMY CONNORS
Converse

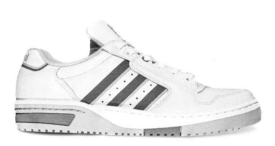

STEFAN EDBERG
Adidas

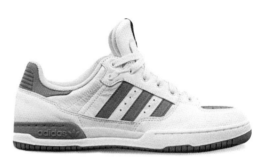

IVAN LENDL
Adidas

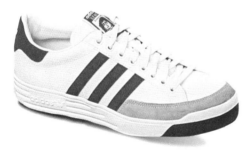

ILIE NASTASE
Adidas

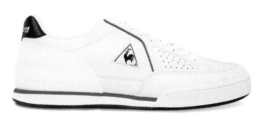

YANNICK NOAH
Le coq sportif

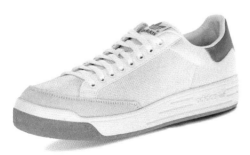

ROD LAVER
Adidas

GUILLERMO VILAS
Puma

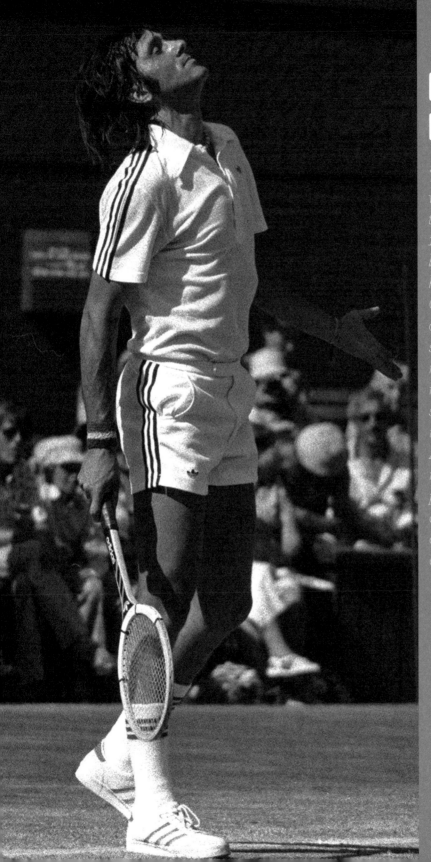

Ilie
Nastase

*The Romanian player,
world number one in
the ATP rankings in
1973, was, above all, the
biggest clown in tennis
history, a Harlem
Globetrotter capable
of the most beautiful
strokes as much as the
funniest pranks or the
most epic rants ever
seen on a court. That
is doubtless why the
Adidas that bears his
name has become so
popular, at tennis clubs
and in gyms, as well as
on the feet of all rebels
of their time..*

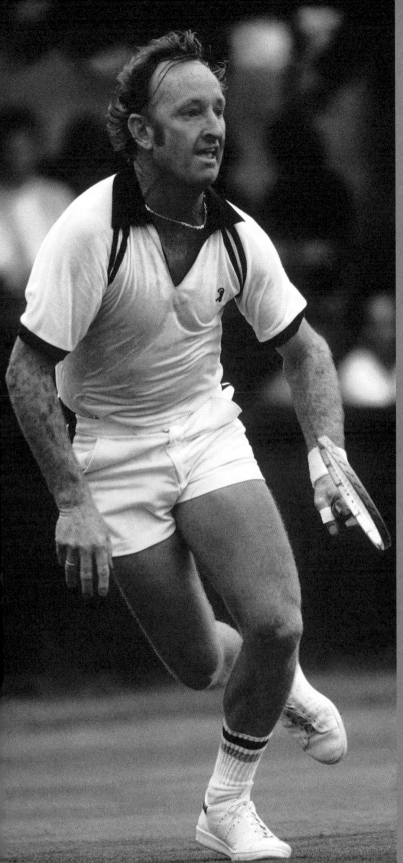

Rod Laver

The lines of the eponymous sneaker are as sleek and simple as this Australian's game. Winner of eleven Grand Slam tournaments in the 1960s and 1970s, Laver was the first true world tennis legend. These days, the Rod Laver shoe is much less common than the Stan Smith, but it is the preferred alternative for all sneakerheads and fashionistas tired of seeing its Adidas cousin worn everywhere.

TOP NBA

Michael Jordan is not the only basketball star of the 1990s to have gotten the world's teenagers to buy pairs of high-top shoes. And just like in comic books or superhero films, he has had some eternal rivals who themselves wore shoes bearing their names (and whom he always ended up defeating).

CHARLES BARKLEY Air Force 180 Olympic
Nike - 1992

PATRICK EWING 33 Hi
Ewing Athletics · 1990

KEVIN DURANT KD 7
Nike · 2014

HAKEEM OLAJUWON The Dream Supreme
Etonic · 1984

SPUD WEBB City Wings
Pony · 1986

KOBE BRYANT X Silk
Nike · 2015

DERRICK COLEMAN Control Hi
British Knights · 1991

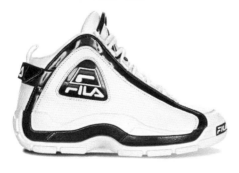

GRANT HILL Grant Hill
Fila · 1996

LEBRON JAMES LeBron 12
Nike · 2014

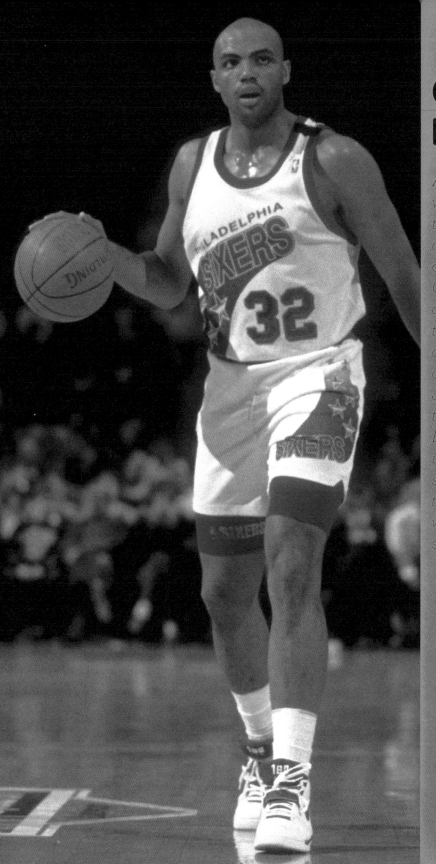

Charles Barkley

A spectacular player who was great at trash-talking on the court, and who always had a quip for the journalists, Charles Barkley was another NBA star of the 1990s. Eclipsed, along with so many others, by Michael Jordan, this member of the Dream Team of the Barcelona Olympics, in 1992, went down in sneaker history thanks to the Air Force 180, which was tough and solid, just like its owner.

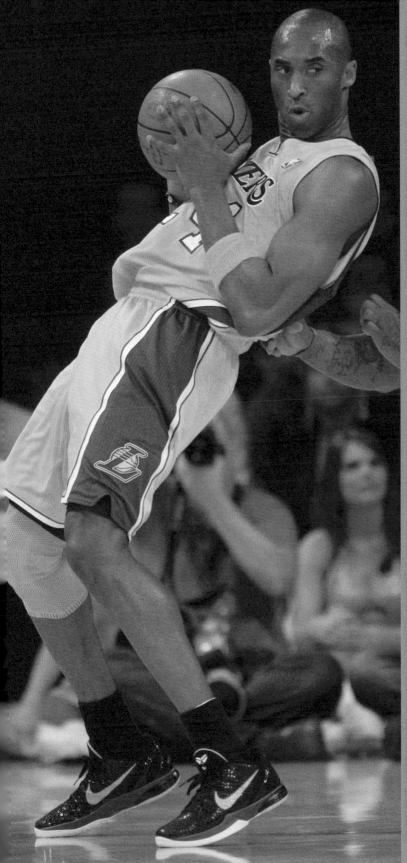

Kobe Bryant

The legendary Kobe Bryant—who died tragically at 41 in a January 2020 helicopter crash—of the LA Lakers (1996 to 2016) succeeded in filling the void left in the hearts of basketball fans when Michael Jordan retired from the courts in 2003. Holder of five NBA Championship rings and two Olympic gold medals, but above all blessed with a style of play that frequently recalled that of "His Airness," the "Black Mamba" was Jordan's worthy heir.

TOP MOVIES

A common sight on sports fields, sneakers have also featured on the big screen.

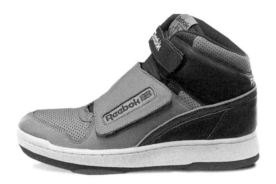

REEBOK Alien Stomper
Alien - James Cameron, 1986

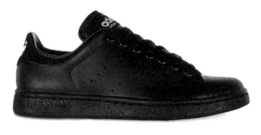

ADIDAS Stan Smith Black
Blade Runner - Ridley Scott, 1982

NIKE Air Flow
Boyz n the Hood - John Singleton, 1991

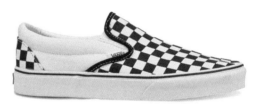

VANS Slip-on Checkerboard
Fast Times at Ridgemont High - Amy Heckerling, 1982

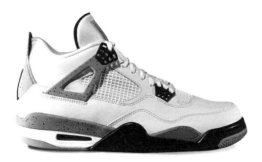

NIKE Air Jordan 4 GS
Do the Right Thing - Spike Lee, 1989

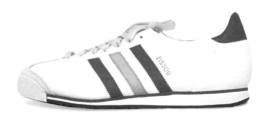

ADIDAS Zissou
The Life Aquatic with Steve Zissou - Wes Anderson, 2004

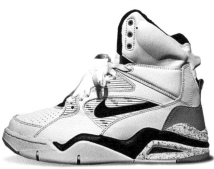

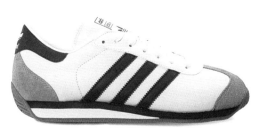

ADIDAS Country
Beverly Hills Cop - Martin Brest, 1984

NIKE Air Command Force
White Men Can't Jump - Ron Shelton, 1992

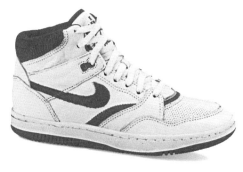

NIKE Sky Force 88 Mid
The Goonies - Richard Donner, 1985

NIKE Air Woven HTM
Lost in Translation - Sofia Coppola, 2003

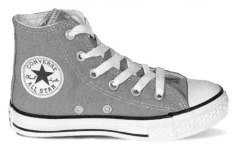

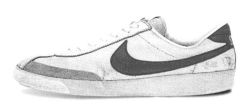

CONVERSE Chuck Taylor All Star
Marie Antoinette - Sofia Coppola, 2006

NIKE Bruin Leather
Back to the Future - Robert Zemeckis, 1985

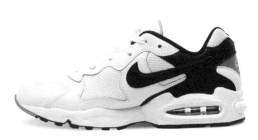

NIKE Air Max Triax
Space Jam - Joe Pytka, 1996

NIKE Vandal
The Terminator - James Cameron, 1984

In Spike Lee's film Do The Right Thing (1989), Buggin' Out, played by Giancarlo Esposito, has his brand new Air Jordan 4 White Cement sneakers trodden on by a passerby, Clifton, played by John Savage. There, then, follows a memorable spat between the two men, with Buggin' Out surrounded by his friends: Ahmad, Punchy, Cee, and Ella. The dialogue reveals the simmering tensions between communities related to the rising gentrification of Brooklyn.

"Not only did ya knock me down, you stepped on my brand-new white Air Jordans I just bought, and that's all you can say is 'Excuse me'?"

Buggin' Out, played by Giancarlo Esposito

TOP BABIES

Sneaker collectors have many rituals, including that of buying three pairs of each new acquisition: one to wear, one for their "museum," and one for ten years time, when the model is no longer sold. The biggest addicts will even buy a fourth one for their (future) offspring.

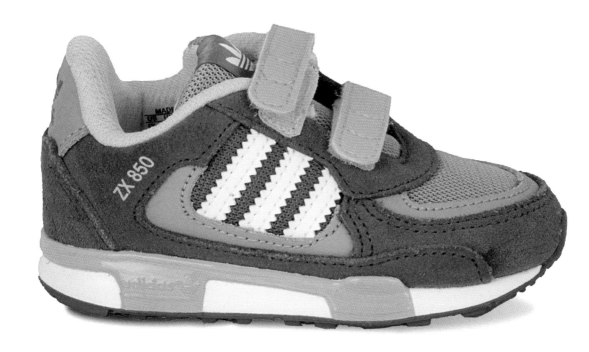

ZX 850
Adidas

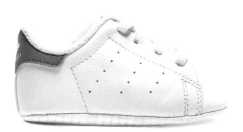

STAN SMITH
Adidas

100 MM
Jon Buscemi

CHUCK TAYLOR ALL STAR
Converse

FIRST COURT
Nike

FREE
Nike

AIR JORDAN
Nike

AIR MAX
Nike

GL 1500
Reebok

TOP FREAKY SNEAKERS

You might not like them all, but every sneaker has a function and a style, not to mention a soul. Well, nearly all of them...

BOOTS KNEE HIGH
Converse

SHAPE-UPS
Skechers

RICK OWENS X ADIDAS
Adidas

GLADIATOR SANDAL
Nike

ZOOM KOBE 3
Nike

NIKEAMES
Ora Ïto

AIR FOOTSCAPE
Nike

ATV 19 + TRAINING SNEAKERS
Reebok

KOBE II
Adidas

TOP SPIKE LEE

Spike Lee is a huge fan of the New York Knicks and Michael Jordan, with whom he shot several commercials for the Nike Air in the 1990s. He is also the most famous collector of Nike shoes. Whenever he appears in public, the film director seems to be wearing a different model; here's a look back at some of his more legendary pairs, whether they be in the colors of his favorite basketball team (orange and purple) or not.

AIR JORDAN SPIZIKE
Nike

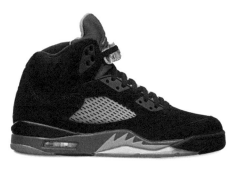

AIR JORDAN 5 BLACK GRAPE
Nike

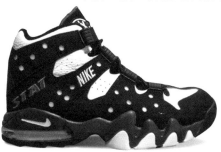

AIR MAX 2 CB 94
Nike

AIR JORDAN 10
Nike

AIR JORDAN XX8
Nike

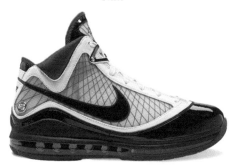

AIR MAX LEBRON VII
Nike

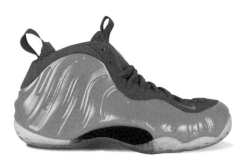

FOAMPOSITE ONE
Nike

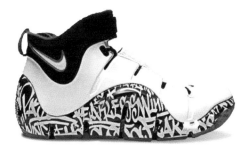

ZOOM LEBRON IV NYC
Nike

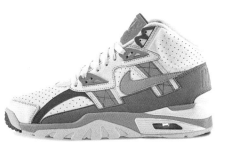

AIR TRAINER SC AUBURN
Nike

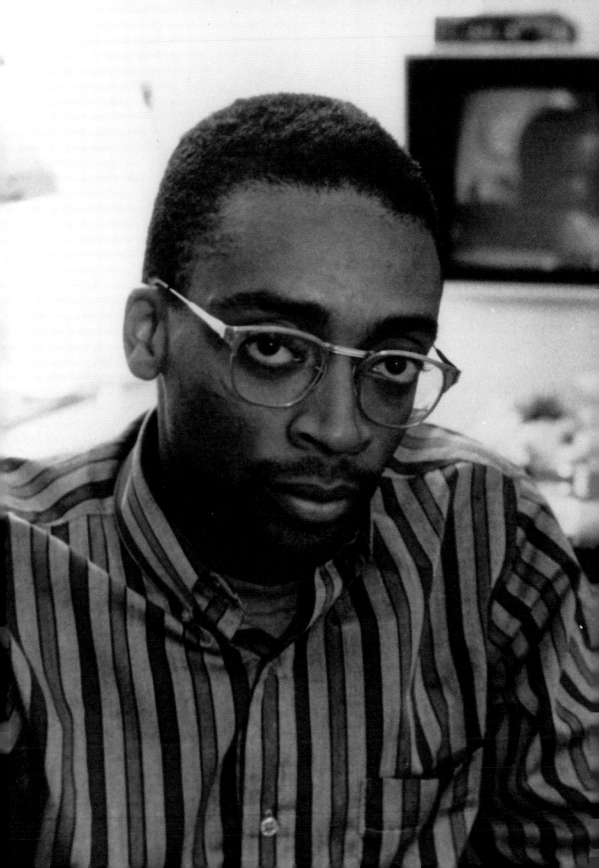

*"It's gotta be
da shoes"*

Mars Blackmon, played by Spike Lee
in his film *She's Gotta Have It*

TOP KANYE WEST

"I'm the most influential person in footwear right now."
So proclaimed the singer and designer Kanye West in
an interview on the famous morning radio show The
Breakfast Club, in February 2015. Designer of the Air
Yeezy—transferred from Nike to Adidas in 2015—West
has an amazing sense of self-promotion, a true eye for
fashion, and, above all, a sneaker collection that is one
of the most complete and most representative of the
many different types and models. Here's a look at his
favorite style, the high-top.

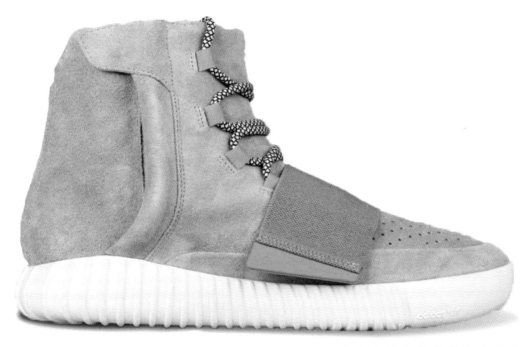

YEEZY BOOST
Adidas x Kanye West

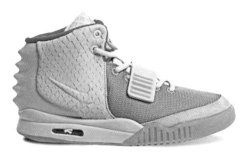

AIR YEEZY 2 PURE PLATINUM
Nike

METALLIC VELCRO HIGH
RAF Simons

HIGH-TOP
Maison Martin Margiela

RED
Balenciaga

COLORAMA
Pierre Hardy

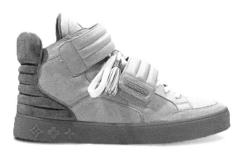

JASPERS (GREY AND PINK)
Louis Vuitton x Kanye West

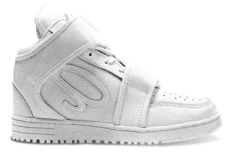

COWHIDE BOOT
Ato Matsumoto

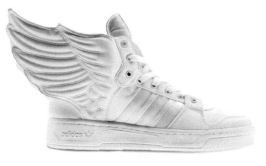

JEREMY SCOTT WINGS
Adidas

The Game Changer

Kanye West's fashion-forward designs and
massive cultural influence have made his
sneakers some of the most highly coveted in the
industry, with collectors paying over $10,000
for a pair of Adidas Yeezy Boost 750s. With
celebrities ranging from Justin Bieber to Jay Z
sporting West's shoes, demand for anything
Yeezy has caused the sneakers to sell out almost
immediately upon their release, and resale prices
have surpassed even Jordans.

TOP FASHION

Although Coco Chanel and Jean Patou were already wearing slim canvas sports shoes in the 1920s, the fashion industry only got into sneaker culture in the early 1980s. At first, models started slipping on pairs of tennis shoes, before designers began creating their own. Now they run the gamut from hyperminimalist to totally eccentric. Here's a roundup of the latest best sellers, and the shoes that are worth a look.

TENNIS FIELD
Burberry

LIZARD
Brooks Brothers

PRIME TENNIS SHOE
Fred Perry

LOUIS PYTHON FROZEN
Christian Louboutin

TRAILBLAZER
Louis Vuitton

101 MATCH HIGH-TOP
Pierre Hardy

AVENUE
Prada

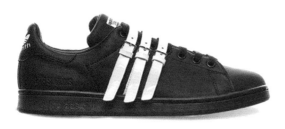

STAN SMITH STRAPS BLACK WHITE 2
RAF Simons

VEJA X BLEU DE PANAME WHITE 2

TOP SMU

Special Make Up (SMU) refers to a shoe designed especially for a specialty boutique. When an artist, a label, or another brand revisits an original model, it's called a collab (collaboration). The result is always eye-catching, as shown in this selection, some of which have been borrowed from the go-to website, Complex Sneakers.

ACRONYM LUNAR FORCE 1 SP PACK
ACRONYM x NikeLab

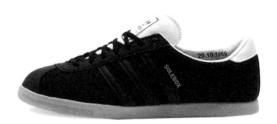

ADIDAS CONSORTIUM X SOLEBOX (BERLIN)

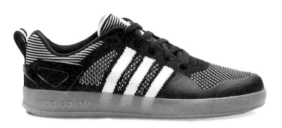

PALACE X ADIDAS ORIGINALS PRO PRIMEKNIT

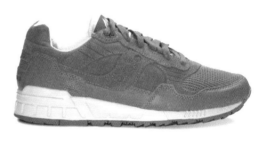

SHADOW 5000
Bodega x Saucony

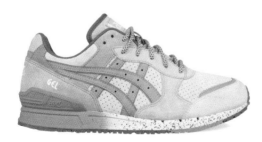

ON THE ROAD
Bodega x ASICS Gel Classic

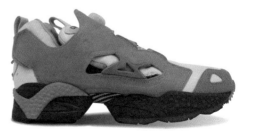

INSTA PUMP FURY
Chanel x Reebok

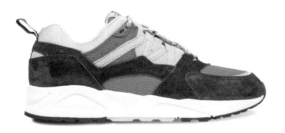

KARHU X PATTA FUSION 2.0

SLIP-ON MURAKAMI X VANS

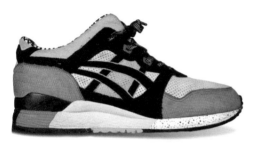

PATTA X ASICS GEL LYTE III

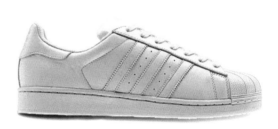

PHARRELL WILLIAMS X ADIDAS ORIGINALS
SUPERSTAR SUPERCOLOR

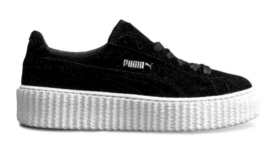

SUEDE CREEPER
Puma x Rihanna

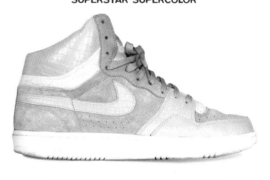

STÜSSY X NIKE COURT FORCE HIGH

SUPREME X VANS OLD SKOOL CAMO

WOOD WOOD X NIKE ACG LUNAR WOOD

TOP FITNESS

Up until the mid-1980s, sports shoe designers would never have imagined that one of their creations would leap out of the stadium and hit the streets. But the world has changed. And the borders between lifestyle and performance are now blurred. These fitness, training, and running shoes might, one day, become must-haves for sneaker addicts.

POWERLIFT 2.0
Adidas

PURE BOOST
Adidas

SUPERNOVA GLIDE
Adidas

SUPERIOR 2.0
Altra

GEL FUSE X
ASICS

GEL-ELATE TR
ASICS

CLIFTON 2
Hoka One One

MEN'S GLYCERIN 13
Brooks

WOMEN'S ADRENALINE GTS 16
Brooks

RUNNING SHOES
Enko

GOLD LUNAR CALDRA
Nike

METARUN
ASICS

ALL OUT CHARGE
Merrell

WAVE RIDER
Mizuno

TOP FITNESS

711 TRAINER
New Balance

FRESH FOAM ZANTE V2
New Balance

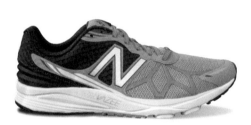

VAZEE PACE
New Balance

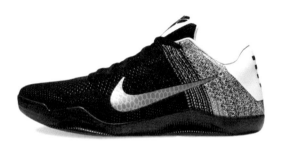

KOBE XI LAST EMPEROR
Nike

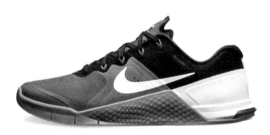

METCON 2
Nike

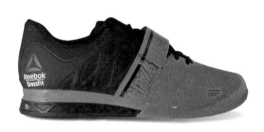

CROSSFIT LIFTER
Reebok

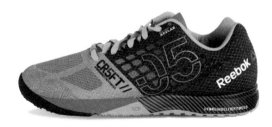

CROSSFIT NANO
Reebok

CROSSFIT NANO PUMP FUSION
Reebok

NYC TRIUMPH ISO 2
Saucony

SKECHERS MEN'S SYNERGY
Power Switch

SKECHERS WOMEN'S FLEX APPEAL
Power Switch

LITEWAVE AMPERE
The North Face

SPEEDFORM APOLLO VENT
Under Armour

CHARGED ULTIMATE
Under Armour

GEMINI 2
Under Armour

SOLANA
Zoot

FLASHBACK 1910 TO 1970

Long before shoes became fashion accessories, their manufacturers thought only about making them as practical as they were comfortable, to help sportspeople in their quest for performance. They never imagined that some of them would go down in posterity.

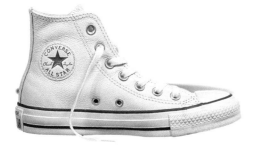

CONVERSE Chuck Taylor All Star
Year released: 1917

CONVERSE Jack Purcell
Year released: 1935

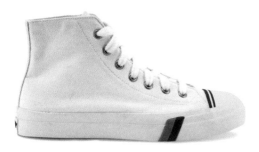

PRO-KEDS Royal
Year released: 1949

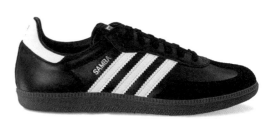

ADIDAS Samba
Year released: 1950

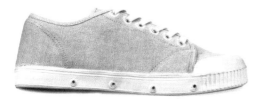

SPRING COURT G1
Year released: 1950

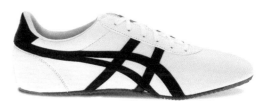

ONITSUKA TIGER Tai-Chi
Year released: 1960

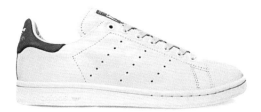

ADIDAS Stan Smith
Year released: 1964

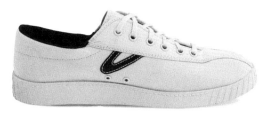

TRETORN Nylite
Year released: 1965

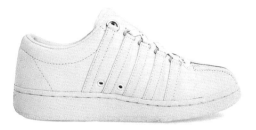

K-SWISS Classic
Year released: 1966

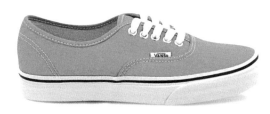

VANS Authentic
Year released: 1966

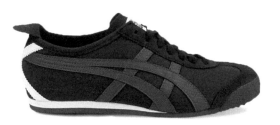

ONITSUKA TIGER Mexico 66
Year released: 1966

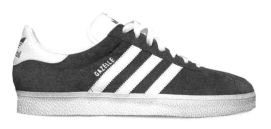

ADIDAS Gazelle
Year released: 1968

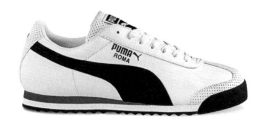

PUMA Roma
Year released: 1968

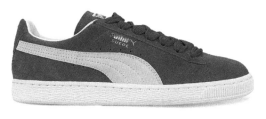

PUMA Suede
Year released: 1968

FLASHBACK
1970s

The rise of the leisure society gave the sports shoe a second life, taking it out onto the street. Hip-hop, an underground culture mad about basketball, grew out of New York City, and made sneakers one of their emblems.

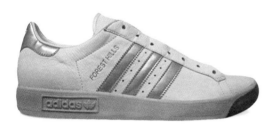

ADIDAS Forest Hills
Year released: 1970

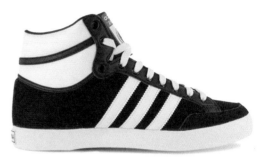

ADIDAS Americana
Year released: 1971

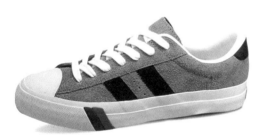

PRO-KEDS Royal Plus
Year released: 1971

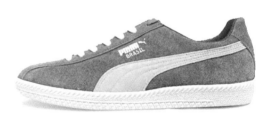

PUMA Pelé Brasil
Year released: 1971

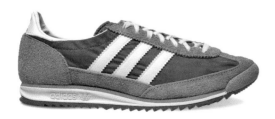

ADIDAS SL 72
Year released: 1972

NIKE Bruin
Year released: 1972

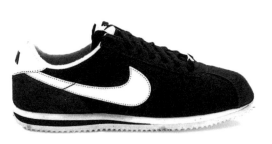

NIKE Cortez
Year released: 1972

NIKE Blazer
Year released: 1972

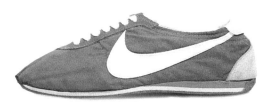

NIKE Boston
Year released: 1973

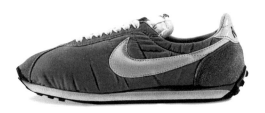

NIKE Waffle Trainer
Year released: 1974

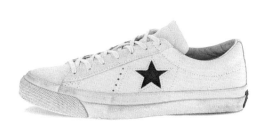

CONVERSE One Star
Year released: 1974

PONY Top Star
Year released: 1974

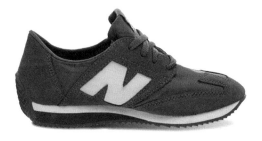

NEW BALANCE 320
Year released: 1976

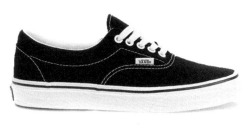

VANS Era
Year released: 1976

FLASHBACK 1970s

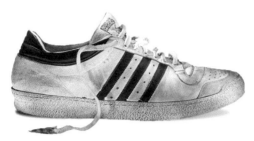

ADIDAS Kareem Abdul-Jabbar
Year released: 1976

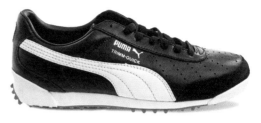

PUMA Trimm-Quick
Year released: 1976

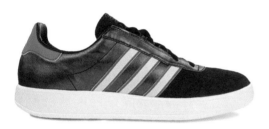

ADIDAS Trimm-Trab
Year released: 1977

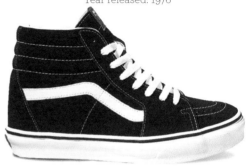

VANS Sk8
Year released: 1978

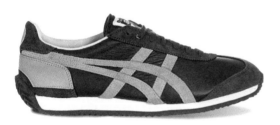

ONITSUKA TIGER California
Year released: 1978

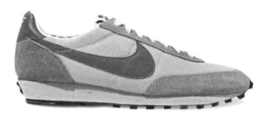

NIKE LDV
Year released: 1978

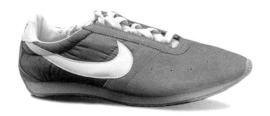

NIKE The Sting
Year released: 1978

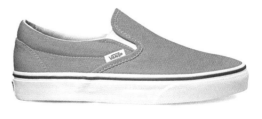

VANS Slip-on
Year released: 1979

ADIDAS Handball Spezial
Year released: 1979

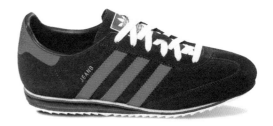

ADIDAS Jeans
Year released: 1979

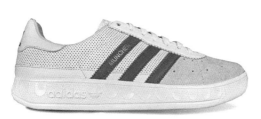

ADIDAS Munchen
Year released: 1979

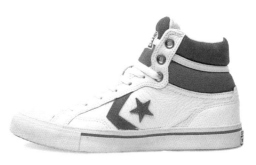

CONVERSE All Star Pro
Year released: 1979

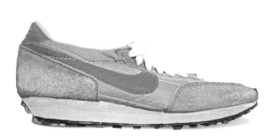

NIKE Daybreak
Year released: 1979

PRO-KEDS Shotmaker
Year released: 1979

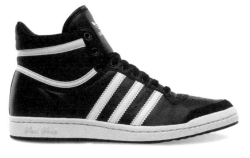

ADIDAS Top Ten
Year released: 1979

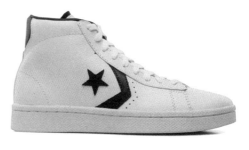

CONVERSE Pro Leather
Year released: 1979

FLASHBACK
1980s

The growth in popular sports and sportswear, combined with the influence of various musical genres, made the sneaker both practical and attractive. This decadent decade would see the release of hundreds of models.

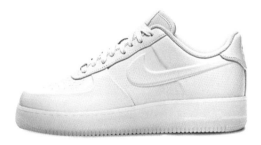

NIKE Air Force 1
Year released: 1982

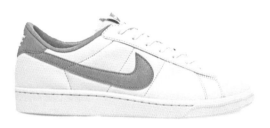

NIKE Tennis Classic
Year released: 1982

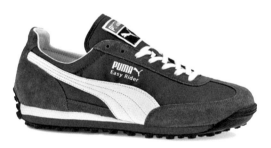

PUMA Easy Rider
Year released: 1982

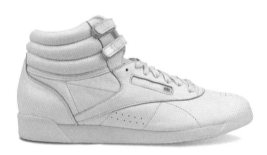

REEBOK Freestyle
Year released: 1982

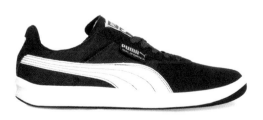

PUMA California
Year released: 1983

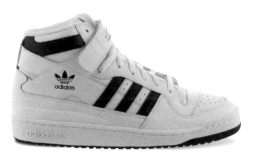

ADIDAS Forum
Year released: 1984

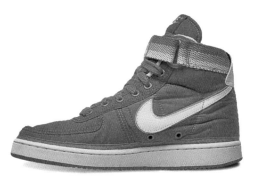

NIKE Vandal
Year released: 1984

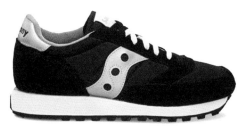

SAUCONY Jazz
Year released: 1984

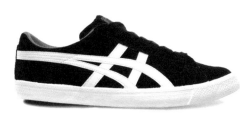

ASICS TIGER Fabre
Year released: 1985

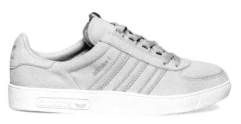

ADIDAS Adicolor
Year released: 1985

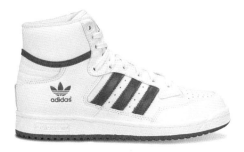

ADIDAS Centennial Mid
Year released: 1985

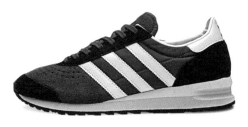

ADIDAS Marathon
Year released: 1985

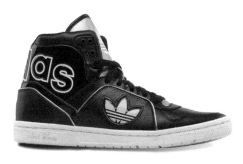

ADIDAS Ecstasy
Year released: 1985

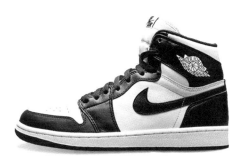

NIKE Air Jordan
Year released: 1985

FLASHBACK 1980s

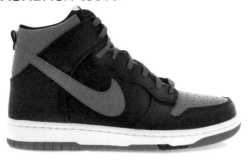

NIKE Dunk
Year released: 1985

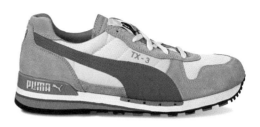

PUMA Tx-3
Year released: 1985

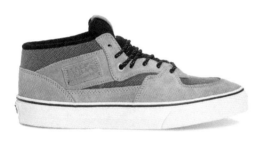

VANS Half Cab
Year released: 1985

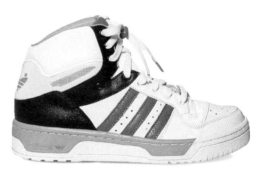

ADIDAS Metro Attitude
Year released: 1986

CONVERSE Weapon
Year released: 1986

PONY City Wings
Year released: 1986

REEBOK Workout
Year released: 1986

REEBOK Ex-O-Fit
Year released: 1987

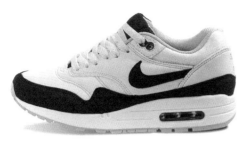

NIKE Air Max
Year released: 1987

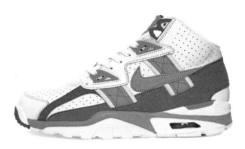

NIKE Air Trainer
Year released: 1987

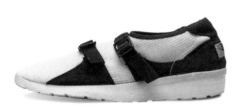

NIKE Sock Racer
Year released: 1987

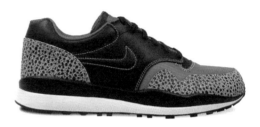

NIKE Air Safari
Year released: 1987

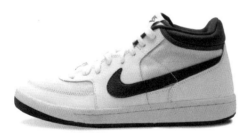

NIKE Challenge Court
Year released: 1987

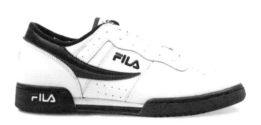

FILA Fitness
Year released: 1988

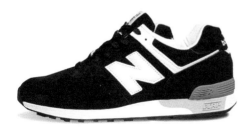

NEW BALANCE 576
Year released: 1988

ADIDAS Superskate
Year released: 1989

FLASHBACK 1990s

The 1990s produced a generation of colorful sneakers with muscular curves, driven by the NBA craze and the race by sports outfitters to rival one another in technology and design.

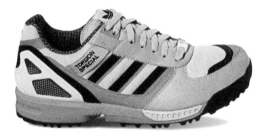

ADIDAS Torsion Special
Year released: 1990

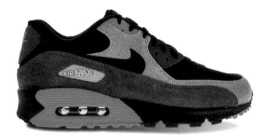

NIKE Air Max 90
Year released: 1990

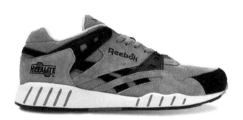

REEBOK Sole Trainer
Year released: 1990

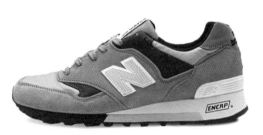

NEW BALANCE 577
Year released: 1990

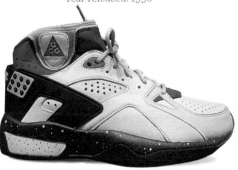

NIKE Air Mowabb
Year released: 1991

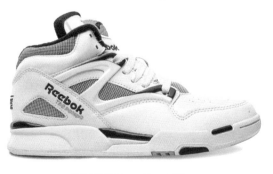

REEBOK Pump Omni Lite
Year released: 1991

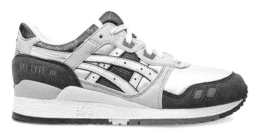

ASICS Gel Lyte III
Year released: 1991

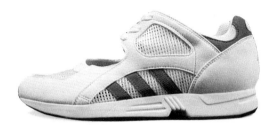

ADIDAS Equipment Racing
Year released: 1991

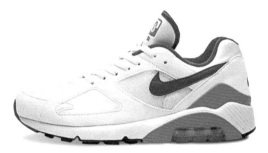

NIKE Air Max 180
Year released: 1991

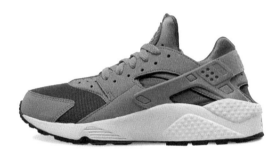

NIKE Air Huarache
Year released: 1991

REEBOK Pump Running Dual
Year released: 1991

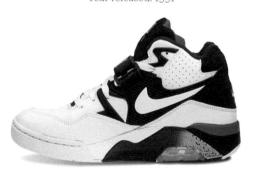

NIKE Air Force 180 Low Olympic
Year released: 1992

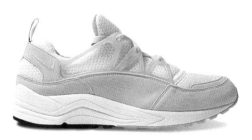

NIKE Air Huarache Light
Year released: 1992

NIKE Air Raid
Year released: 1992

243

FLASHBACK 1990s

AIRWALK Jim
Year released: 1993

ADIDAS Tubular
Year released: 1993

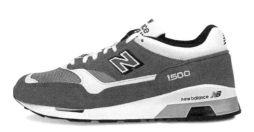

NEW BALANCE 1500
Year released: 1993

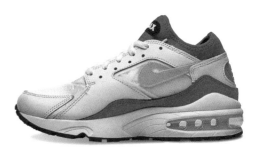

NIKE Air Max 93
Year released: 1993

NIKE Air Trainer Huarache
Year released: 1993

A BATHNG APE STA
Year released: 1993

ADIDAS Dikembe Mutombo
Year released: 1993

PUMA Disc Blaze
Year released: 1994

NIKE Air Rift
Year released: 1995

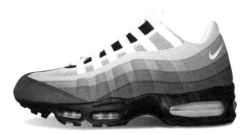

NIKE Air Max 95
Year released: 1995

NIKE Air Footscape
Year released: 1995

NIKE Air More Uptempo
Year released: 1996

NIKE Air Max 97
Year released: 1997

NIKE Air Zoom Spiridon
Year released: 1997

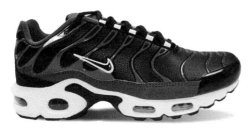

NIKE Air Max Plus
Year released: 1998

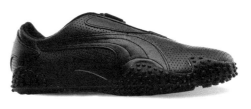

PUMA Mostro
Year released: 1999

FLASHBACK
2000s

Although designers were still innovating, with a few, often ephemeral, successes, the trend was toward a seemingly infinite reinterpretation of cult models by sports stars, artists, and even other brands.

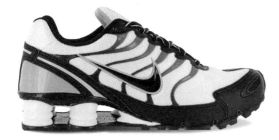

NIKE Shox 4
Year released: 2000

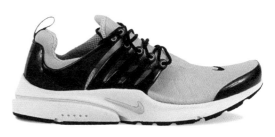

NIKE Air Presto
Year released: 2000

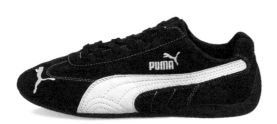

PUMA Speed Cat
Year released: 2001

ADIDAS Climacool
Year released: 2002

G UNIT G-6 Hunter
Year released: 2003

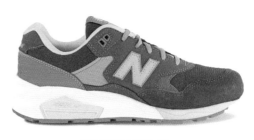

NEW BALANCE 580
Year released: 2003

CREATIVE RECREATION Cesario Lo
Year released: 2003

FILA Vulc 13
Year released: 2003

REEBOK S. Carter
Year released: 2003

ADIDAS Y-3 Basketball High
Year released: 2004

NIKE Sock Dart
Year released: 2004

ADIDAS Ultra Ride
Year released: 2004

ADIDAS Y-3 Hayworth
Year released: 2006

LAKAI Telford High Rob Welsh
Year released: 2006

FLASHBACK 2000s

A BATHING APE X KAWS Chompers
Year released: 2006

ALIFE X REEBOK Court Victory Pump Ball Out
Year released: 2006

ETNIES X IN4MATION Rap High
Year released: 2006

JEREMY SCOTT X ADIDAS Money Runway
Year released: 2007

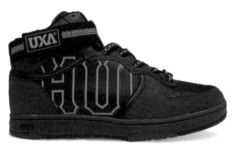

DVS X UXA X HUF Huf 4 Hi
Year released: 2007

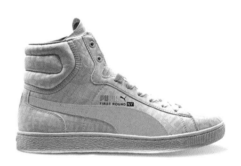

ALIFE X PUMA First Round
Year released: 2007

VANS SYNDICATE X WTAPS Bash
Year released: 2008

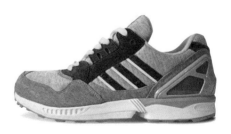

VA X ADIDAS ZX 9000 A to ZX
Year released: 2008

CONVERSE Skateboarding CTS Low
Year released: 2008

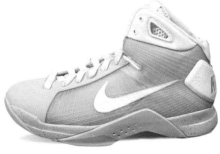

NIKE Hyperdunk Supreme McFly
Year released: 2008

SUPRA FOOTWEAR Skytop Tuf
Year released: 2008

NIKE Air Yeezy 1
Year released: 2009

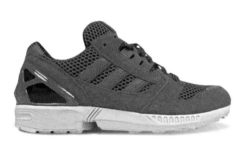

ADIDAS David Beckham ZX 8000
Year released: 2009

GOURMET Une
Year released: 2009

ETNIES Metal Mulisha Fader
Year released: 2009

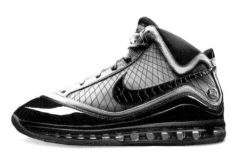

NIKE Air Max LeBron VII
Year released: 2009

FLASHBACK
2010s

The worldwide running boom disrupted the trends, with certain models being able to leap instantly from the track to the street. There was an explosion in the number of collaborations and rereleases, with consumer customizations creating new species in the sneaker jungle.

REEBOK Zig
Year released: 2010

NIKE Flyknit One +
Year released: 2012

NEW BALANCE 999
Year released: 2012

NIKE Roshe
Year released: 2012

ADIDAS ZX Flux
Year released: 2013

NIKE Free 5.0 V5
Year released: 2013

REEBOK L23J
Year released: 2013

NIKE Trainerendoor
Year released: 2013

ADIDAS Pure Boost
Year released: 2014

NIKE Air Jordan Future
Year released: 2014

NIKE Flystepper
Year released: 2014

ADIDAS Ultraboost
Year released: 2015

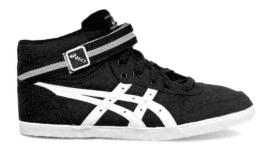

ASICS Kaeli
Year released: 2015

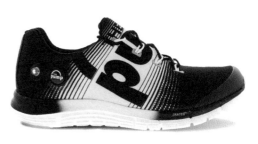

REEBOK ZPump Fusion
Year released: 2015

MUST-HAVES 2015-2020

The sneaker business never stops, with one trend giving way to another in rapid succession. Here is a selection of iconic sneakers released since 2015, from updated models to limited editions, and true innovations.

ADIDAS Continental 80
Year released: 2018

ADIDAS Nite Jogger
Year released: 2019

ADIDAS Ozweego
Year released: 2019

ALLBIRDS Wool Runner
Year released: 2016

BALENCIAGA Triple S
Year released: 2017

FILA Disruptor 2
Year released: 2018

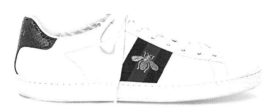

GUCCI Ace
Year released: 2015

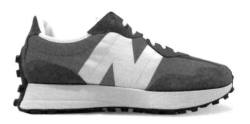

NB 327
Year released: 2020

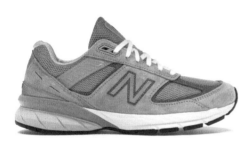

NB 990V5
Year released: 2019

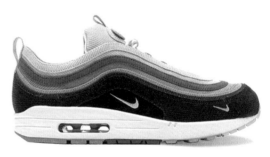

NIKE Air Max 1/97 Sean Wotherspoon
Year released: 2018

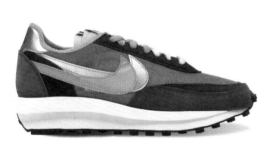

NIKE Sacai
Year released: 2019

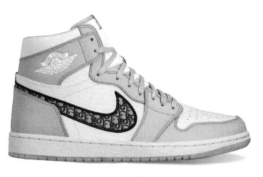

NIKE Air Jordan x Dior
Year released: 2020

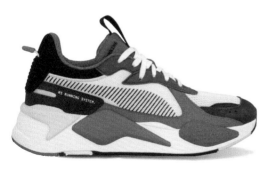

PUMA RS-X
Year released: 2018

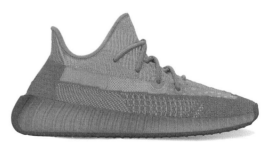

YEEZY Boost 350 V2 Eliada
Year released: 2020

GLOSSARY

Arch: section between the heel and the forefoot

B-grade: sneaker with one or several defects, but not a counterfeit

Camp out: camping in front of a store in order to obtain a particularly sought-after model, generally a limited edition

Capsule: small collection designed by someone from outside of the brand

Consortium: limited editions sold in top stores

Deadstock: a new pair, in perfect condition, of a model that is no longer on general sale. If a pair has been worn but is still in very good condition, it is called "near deadstock"

Deubré: ornamental metal shoelace tag centered between the first pair of eyelets closest to the toe

Eyelets: circles (often metal or plastic) that reinforce the holes through which the laces pass

Fit: all of the characteristics of a shoe that enable a foot to sit comfortably within it

General release: shoes that are available in all stores

High-top: a sneaker with an upper extending above the ankle

Hyperstrike: an extremely limited edition, perhaps not even fifty pairs, that is often the result of a collaboration

Insole: sole-shaped piece, placed inside the shoe, on which the foot directly rests

Legit: authentic sneaker. A counterfeit might be called a "fake" or a "variant"

Low-top: sneakers that are typically cut below the top of the ankle

Mesh: a knitted fabric, made of canvas or synthetic fibers, that improves breathability and can be used instead of traditional leather, usually on the vamp part of the upper

Mid-top: sneakers that are typically cut halfway between low- and high-tops

Mint: new pair

OG: original model, first edition. Used to differentiate the original model from a rerelease

Player sample: a prototype sneaker produced for an athlete, and not intended to be sold

Shape: general appearance of the shoe

Sneaker addict: a major sneaker fan or collector

Special Make Up (SMU): a model created specially for a store

Stiffener: semirigid reinforcement placed at the back of the shoe to support the rear of the foot

Suede: leather made from the underside of a skin; it is softer but less tough, and gets dirty more easily

Toe box: the part between the bottom of the laces and the tip of the shoe—called the "mudguard" or "splashguard"

Tongue: the part of the upper that covers the instep and protects the foot from the tightening system (laces, zip, Velcro)

Upper: the part of the shoe above the sole comprising the vamp, the tongue, and the lacing/closure section

Vamp: front part of the upper, covering the instep and the toes

Wedge sneakers: sneakers with wedge soles

PHOTOGRAPHIC CREDITS

Printed in Hong Kong